THE SLEEVE SHOULD BE ILLEGAL

& Other Reflections on Art at the Frick

FOREWORD BY ADAM GOPNIK

EDITED BY MICHAELYN MITCHELL

THE FRICK COLLECTION IN ASSOCIATION WITH DELMONICO BOOKS · D.A.P. NEW YORK

CONTENTS

4 A museum director's day is ruled by meetings. To offset these administrative duties, I have adopted the practice of wandering through the Frick's galleries once a day and, sometimes purposefully but more often randomly, picking one work of art to focus on for a length of time. In the beginning, the motivation was to remind myself of what brought me into this field in the first place, a love of art. Fifty years' experience as an art historian, curator, and now director has certainly deepened the knowledge I can bring to bear on the analysis of a painting, sculpture, or decorative art object. Nonetheless, the value of looking at art is that one is continually learning from it. Increasingly, I find myself viewing the Frick's collection through the experience of recent temporary exhibitions we have mounted or programs we have organized. Looking now at Turner's *Harbor of Dieppe: Changement de Domicile*—after our exhibition *Turner's Modern and Ancient Ports: Passages through Time*—reminds me of what I learned from the show: that the use of a new pigment, chrome yellow, in the 1820s influenced the luminosity of Turner's works and also that—after the Britons were free again to travel following the end of the Napoleonic Wars—images of continental ports achieved increased symbolic importance. When I step into the Fragonard Room these days, I often think of the film *The Progress of Love*, written several years ago for the Frick Film Project—a collaboration between the Frick and the Ghetto Film School—by sixteen-year-old Gabby Martinez. Gabby's film is a cry against the orderly chapters of the love story presented by the French Rococo painter.

One's mind often wanders when looking at a work of art. As someone responsible for the care and interpretation of the collection, I may start thinking: Has the varnish yellowed so much that the painting needs cleaning? Can we improve the way it is lit? Should we lend it to the museum in The Hague? How do we communicate a new scholarly discovery about the work of art to our general audience? As director, I also have the privilege of walking the galleries whenever I want. It is then, usually at night, that I think about the man who built the house and bought the art, Henry Clay Frick, sitting on a sofa, smoking a cigar, and regarding the portraits of saints and sinners he

quite deliberately placed in the Living Hall. What did this tough businessman see in these works, and why did he buy these particular ones?

The longer I look, the more my observations turn back to the artist's skill and to my personal reaction. The scumbled paint, for instance, that Velázquez somehow transformed into King Philip IV's embroidered jacket triggers an aesthetic and emotional response. The very first painting I remember seeing was at the Prado in Madrid, Velázquez's *Las Meninas*, then theatrically presented opposite a mirror. My six-year-old imagination transported me then into the darkened Spanish palace room among princesses and dwarves. As a graduate student in New York, I fixated, for some reason, on the elegant, nervous fingers of Frans Snyders as portrayed by Van Dyck in the painting in the Frick's West Gallery.

I ask myself then, which picture would I have written about for this anthology? For a short book called *Director's Choice*, I had to pick thirty-seven works from the collection. These were hard enough to select. Now, what I remember most is the one that didn't make the cut, which I still mourn not including: Titian's *Portrait of a Young Man in a Red Cap*. Perhaps it's in part because when I first laid eyes on it, I saw myself as the dreamy youth.

It is with reveries like these that I climb the stairs back to my office, realizing once more that there is no one way to look. We see artworks through the lens of what we bring to them and what we are seeking. It is therefore no surprise that the responses in this anthology are as varied as the world the art reflects.

Finally, my deepest thanks to The Arthur F. and Alice E. Adams Charitable Foundation, whose support made it possible to publish this book.

Ian Wardropper
Anna–Maria and Stephen Kellen Director, The Frick Collection

PICTURES AT AN INSTITUTION

Adam Gopnik

Once upon a time, the ekphrasis was the standard, even the highest, form of art writing—an ekphrasis being the poetic evocation of a painting by a poet who had been sufficiently impressed by a picture to want to write about it. Phrases and paragraphs poured out about pictures in antiquity, evocations and intimate descriptions of this painter's landscape or that one's lover. Philostratos of Paros, we're told, wrote a book detailing the appearance of forty-five pictures, and Plato thought the form essential to the dialogue between poetry and art. Right through the Renaissance—it is one of the key elements in the revival of classical learning—and well on into the nineteenth century, the idea that one paid homage to art by inventorying a picture's contents in order to evoke its mood, articulating the grammar of a picture in a grammar of words, was one that connected writer to painter and art to art. In many ways, it was the chief means of connecting language to imagery—not merely offering word painting but word painting *about* a painting. Ariosto described Merlin's (imaginary) picture gallery; Vasari described the artist's pictures in each of his lives; and, at the end of the nineteenth century, Walter Pater could make his reputation by finding words for Leonardo's *Gioconda*: "She is older than the rocks among which she sits . . ."

No more. The gift of evoking the first-hand experience of art, rather than imposing its social-historical-material-whatever context upon it, is not merely antiquated but, with one or two notable exceptions, actively discouraged in academia. What we want, miss, is not what *you* see when you look at the picture but what its time saw in it (which usually means what the professor wants the time to have seen in it). I recall, in my own misspent youth in art history, confiding to a fellow student that I wanted to study art history because I hoped to register in prose the overwhelming responses that certain works of art evoked in me. He looked at me with genuine concern and puzzlement: "Oh, you mean art *appreciation*," he said at last. I suppose I did, at that.

Some of us still try. John Updike filled two books of art writing with amiable ekphrases, while the late and much missed Robert Hughes had an unequaled ability to catch a

style in a single sentence—and this writer, when he moved on from unsuccess in art history to a brief bath as an art critic, tried once to sing three thousand words to a single Wayne Thiebaud cake painting. No time can be so drained of aesthetic experience

as to leave the ekphrasis completely unpracticed. The alacrity with which the varied individuals who contribute to this collection jumped into the attempt—mostly with both feet first and a loud enthusiastic splash—suggests the appeal of the ekphrastic example. Pictures really do excite emotions in us, and the urge to put those emotions down is often unstoppable.

The Frick Collection, which provoked this particular bouquet of ekphrastic efforts, lends itself to that kind of scrutiny and appreciation perhaps more than any other collection in America. It doesn't change, or doesn't seem to, and so invites repeat visits not just of ourselves but of our sensibilities. (In fact, as its keepers and curators patiently explain, there is much more movement within and around the collection than the amateur visitor sometimes notices or, perhaps, wants to notice.) We wander through the Frick, focused on old friends. We know its twists and turns, and we age with the pictures. The old reproach given to the ekphrastic writer, or just to the poor damned art appreciator, is that the response in their minds takes precedence over the actual signal sent by the artist. But this is a dubious picture of how information arrives in our minds—which is not by signals unequivocally sent from the past to our present but through a complicated set of unsolvable equations in which the past itself is always changing while the self that receives it is changing too. The hopeful spirit of youth that resides in *The Polish Rider* feels very different at twenty-two than it does at sixty-two. We live within pictures, and among pictures, not merely in front of pictures. (And then, is *The Polish Rider* really a Rembrandt at all? Whose hand was on the telegraph to begin with, tapping out the code?)

The eternal task of description is to find language that in some way parallels the thing seen. (It can never quite *match* it.) The great jazz writer Whitney Balliett—who had the gift, unique in my experience as a reader, of being able to describe what music sounds like—once confided to a lecture hall that you could use language to make another form felt either through extravagant metaphor or by pointillist segmentation.

Either you said that a Ben Webster sax solo picked you up like a wave and settled you down surprisingly on a beach, or you tried to capture each moment in the passing solo—its sweeping turn, its sudden lurch, its breathy half-audible finish.

This seems to be a good rule for the description of paintings as well. Reading through these short texts, it seems that we describe best by breaking a thing down to its parts or finding the one right simile to capture its whole. André Aciman disaggregates and finds a mark in Corot that is "like a subtle hint of lipstick on a stunning face, like an unforeseen afterthought, the mark of genius that reminds me each time that I like to see other than what I see until I notice what's right before me." Simon Schama, on the other hand, inventories the whole of a Turner to get the Turner down: "signs of drowsy ease; a besom lies on the grass; a wheelbarrow awaits the sweet-smelling trimmings; the 'Limes' (or linden trees) that gave their name to Moffatt's house, spread like parasols out of their pollarded length of trunks. And at the end of the little avenue, two men, perhaps the rich brewers, stand in easy conversation: one with his face to us, the other leaning as one would over the low wall watching the shift of silvery water. An opening leads down to the implied dock."

Yet though these texts don't have, or seek, a homogeneity of tone, they do show a uniformity of purpose. All of them, for all the variety of sensibilities and political leanings they contain—taking us from Moeko Fujii recalling how her Japanese mother became entangled in a Vermeer to Dame Diana Rigg telling us of how Rembrandt's incomparable self-portrait informs her acting—strikingly seem to settle on a single shared strategy. It is to look at a picture, remember how one first experienced it—or how one was first introduced to it—survey one's subsequent experience of it, and try to bear down, through the superimposition of all these moments, on what the picture might actually be like. We all locate pictures not in their created moment alone but in the intersection of two moments, theirs and ours. The end throughout, conscious or not, is to trace the connection, however minute, between you and the picture, like two Venn diagrams just overlapping, a tiny curve of intersection, but enough.

The superimposition of times that these texts possess returns us, perhaps more meaningfully, to the ancient question of what pictures are *good* for. The idea of pure aesthetic experience has been dislodged from its once strong place; yet the reverse idea, of pictures as pathways into social history, seems empty too. As illustrations of social history, good pictures are, in truth, impoverished: no single picture will tell you remotely as much about a time as a decent round of data. Pictures are distorting mirrors, and trying to "correct" the distortion in turn distorts the art. (Listing the absences in the picture is a losing proposition, since the category of absences is always infinite.)

It seems, to corroborate the testimony in these new-generation ekphrases, that we go to pictures not for time lost or time past but for time leveled, with the strange intuitive certainty that they exist in several temporal dimensions at once. The great thing about pictures is not that they are "timeless" but that they are implanted in one time and persist into another, are there then and right here right now. A work of art is a secular miracle of simultaneity. All art is time travel of a kind; but with pictures, the membrane between time past and time present is almost hallucinatory in its transparency. Music must be re-created, books crumble and must be reprinted; pictures are just there. Bellini's *St. Francis in the Desert* is in a fifteenth-century Venetian pictorial imagination of thirteenth-century Umbria—and here off Fifth Avenue in New York. Where music is abstract emotion, emotion distilled into a fragrance, and books, however much we love reading, demand a leap between black-and-white letters and perceived experience, pictures really do depict. The oldest of metaphors for pictures holds: they are windows onto another time.

A beautiful image from contemporary physics supposes that we live within a multiverse, where all possible moments—all our life choices and every electron's twists and turns—exist simultaneously, and the unidirectional passage of time that seems to point our lives in one direction becomes a fiction of our confinement; when we witness quantum uncertainty, we are seeing the bubbles on the surface of the champagne of many worlds. The "arrow of time" is an illusion, and times past are still present—if we could have a single moment of absolute clarity, see the multiverse from, so to speak, God's point of view, we would see all times simultaneously

adjacent. In a moment of absolute perception, we would see every moment in our lives at once, each placed beside the other, all still living. Times past, present, all possible times, on an equal footing.

In other words, the multiverse itself, if we could only see it, would look . . . well, like a picture gallery, almost precisely like the Frick, each small window onto time immediately adjacent to the next one. God's point of view, outside the boundaries of time, is ours as gallery-goers—which may be why we favor it so much and keep going back to art galleries. The evocations of pictures contained in this book remind us of the astonishing truth that the timelier art is, the more timeless it becomes, the more lodged in one window, the more available now. Gallery going is the only reliable form of time travel we possess. *You are here,* the limited map in the mall explains to us. You are everywhere, the pictures at the Frick insist. And we are.

ANDRÉ ACIMAN

Jean-Baptiste-Camille Corot, *Ville-d'Avray*, ca. 1860

On a late November morning years ago, we crossed Central Park. I remember the bare trees along the way and the glacial air and the sodden earth underfoot, and I remember unleashed dogs scampering about in the mist with steam rising from their snouts while their owners stood jittering, rubbing their palms. When we reached Fifth Avenue, we scraped the mud off our shoes, entered The Frick Collection, and before we knew it, were facing Corot's *Ville-d'Avray* and moments later Corot's *Boatman of Mortefontaine* followed by Corot's *Pond*. I had seen the paintings several times before, but this time, perhaps because of the weather, I realized something I'd never considered. I was about to tell my friend that Corot had captured Central Park perfectly, that looking at the boatmen in the paintings reminded me of the scene we'd just left behind by the deserted Boat Basin on 72nd Street, when I realized that I had gotten things entirely in reverse. It was not that Corot reminded me of the park, but that if the park meant anything to me now it was because it bore the inflection of Corot's subdued melancholy. Central Park suddenly felt more real to me and was more stirring, more lyrical, and more beautiful because of a French painter who'd never even set foot in Manhattan. I liked the cold weather more now, the dogs, the scrawny trees, the damp and barren landscape that no longer felt late autumnal but that was starting to glow with peculiar reminders of early spring. New York as I'd never seen it before.

But just as I was about to explain this reversal, I began to see something else. I remembered the Ville-d'Avray I had visited as a young man, years earlier in France, and how I'd been struck by its beauty, not because of the town and its natural environs but because of Serge Bourguignon's depiction of it in his 1962 film *Les dimanches de Ville-d'Avray* (a.k.a. *Sundays and Cybèle*). Now, the film too was imposing itself on Corot and on New York, and Corot himself was being projected back on the film. Only then did I realize that what truly attracted me to the paintings was something I'd never observed before and which explains why—despite all these mirrorings and reversals and despite the sky verging on the gray and the untended landscape over which hovered Corot's muted lyricism—what I loved in each painting and what had suddenly buoyed my mood was something I'd never noticed before: a mirthy spot of red on the boatman's hat. That hat caught my attention like an epiphany on a gloomy day in the country. Now it's what I come to see each time I'm at the Frick and why I love Corot. It's the tiny coin in the King Cake, like a subtle hint of lipstick on a stunning face, like an unforeseen afterthought, the mark of genius that reminds me each time that I like to see other than what I see until I notice what's right before me.

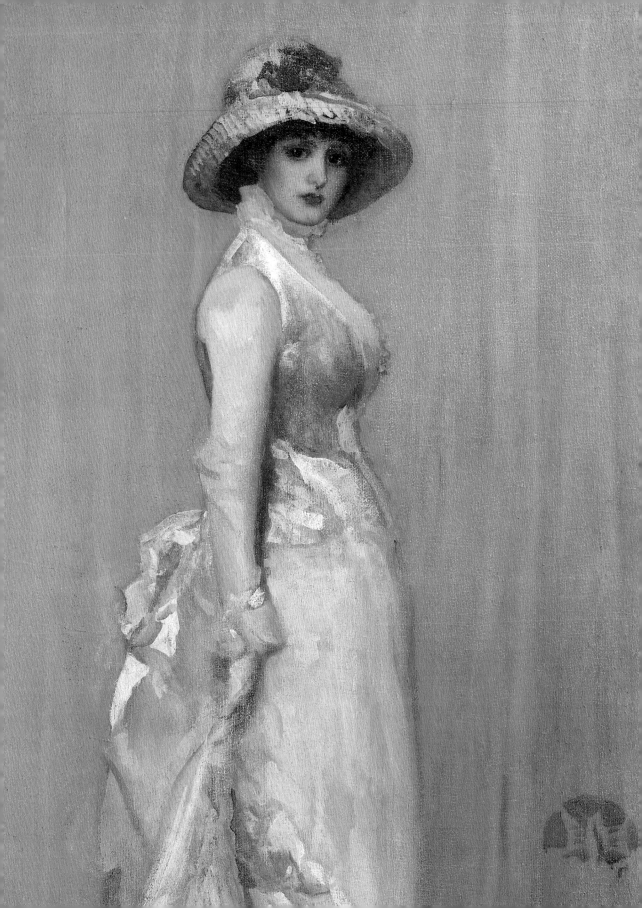

IDA APPLEBROOG

James McNeill Whistler, *Harmony in Pink and Grey: Portrait of Lady Meux*, 1881–82

When I was a child, many years ago—I've just turned ninety—school trips to museums were unknown. Museums were not something I even knew existed. The Frick was a late discovery in my life. Its collection is the real thing, and I've spent many hours in ecstasy there.

As an art student, I put in many hours of figure drawing. The model was always a naked female. I used to wonder how she could pose in stillness for so many hours. What could she be thinking? Who was she?

Harmony in Pink and Gray shows Lady Meux standing before a curtain wearing a rather large hat and a gray dress trimmed in pink satin. The butterfly emblem that Whistler used as a signature is on the right side of the painting.

Lady Meux was the daughter of a butcher, a banjo-playing barmaid who amused patrons at the Casino de Venise, where she met her future husband, Sir Henry Bruce Meux, a brewer. Having married into the upper class, she was never accepted by her husband's family. She courted controversy by driving herself around London in a sporty open carriage drawn by two zebras. Bold and arrogant, she created a sensation by appearing at a hunt riding an elephant. She owned thoroughbreds, adopting the name of Mr. Theobolds to enter them in races. The Meux house was sumptuous, including a swimming pool and an indoor roller skating rink. Contrary to a woman's primary role as mother, Lady Meux had no children.

It is said that it took Whistler about forty hours to paint a portrait. I marvel at this endurance on the part of Lady Meux to stand hour after hour. What lies just outside the pose? Perhaps another world. Standing for so many hours in silence, I imagine myself being in chaotic thought, wandering through memories of childhood, humming limericks . . . jabbering, joking, and ranting in my mind as I skip through poems, porno fantasies, raw desire. I admire her.

Whistler was one of the most accomplished portraitists of his time. However, he filed for bankruptcy in 1879, following his lawsuit against the critic John Ruskin. In 1881, Lady Meux offered Whistler his first significant commission after the bankruptcy, which resulted in three paintings of her. The first portrait is in the Honolulu Museum of Art. The second, to which I feel a personal connection, belongs to the Frick. The third portrait was destroyed by the artist before completion as the result of a comment made to him by Lady Meux.

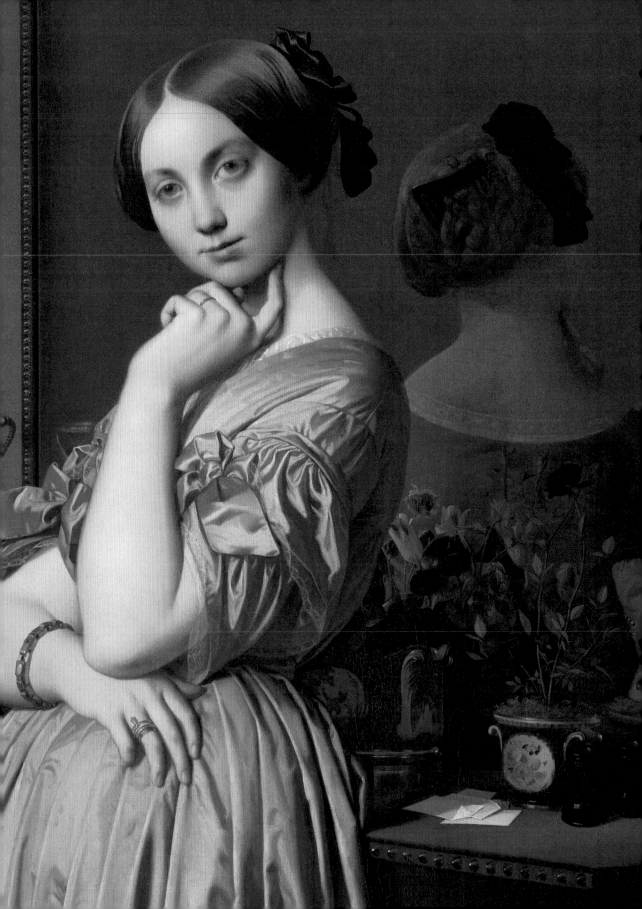

FIRELEI BÁEZ

Jean-Auguste-Dominique Ingres, *Comtesse d'Haussonville,* 1845

Painted with such loving detail, the countess—glossy, soft, and cold—beckons the viewer to come closer with her bare hint of a smile. A self-professed femme fatale. The composition becomes a seduction in details, Ingres's imagined ideal of this pale and ever-poised young woman.

Her flushed cheeks and shadowed under-eyes signs of a long night about town. The calling or dance cards coquettishly placed on the mantel behind her traces of time happily spent. All ending in Ingres's framed moment, where both he and the viewer, outside the mirror's reflection, are invited by the echoed hand gesture to focus on the delicate pulse point at her neck, perhaps to lean in for a kiss.

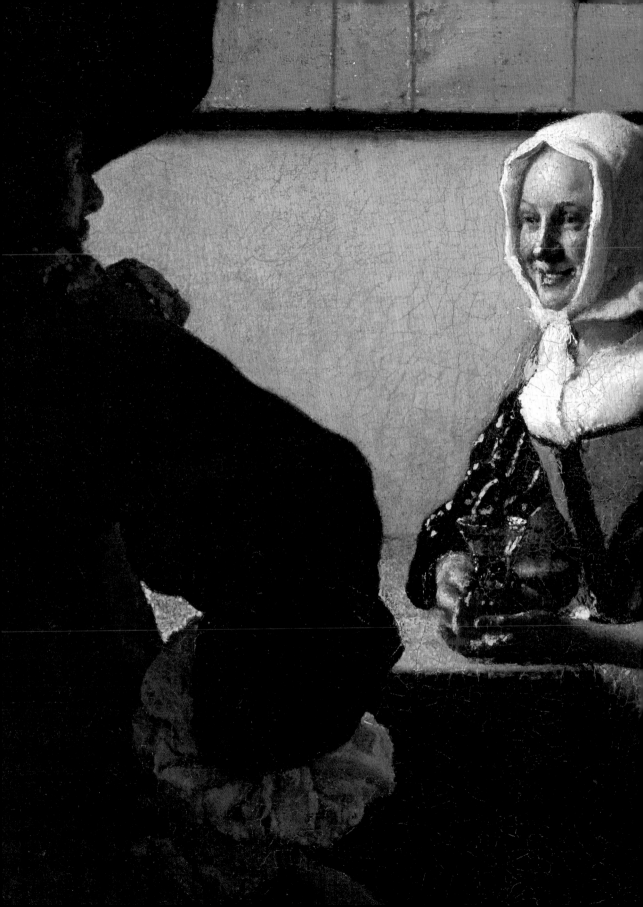

VICTORIA BECKHAM

Johannes Vermeer, *Officer and Laughing Girl*, ca. 1657

As a relative newcomer to the world of Old Masters, I have spent time questioning, absorbing, and trying to understand more about this world of art I have been so lucky to be introduced to. The Frick has given me so many wonderful moments and taught me so much. In my wanderings in the galleries, I have found some pieces I love for their aesthetic qualities, some I love because they appeal to the intellect, and some I love purely for their storytelling.

But Vermeer's *Officer and Laughing Girl*—at the base of the grand staircase—meets all of those criteria. It is the painting I've looked at the longest, the one I keep going back to for one more look, the one that captivates me. Its depiction of a moment in time is simply one of the most beautiful things I've ever seen. It also allows me to draw my own conclusions about its narrative.

I started reading about the painting because I had so many questions, and my questions seem to have been the same ones that others have had. Who is the girl? Why is she smiling? What was she doing before the officer sat down? How has the officer come upon her? What's outside the window? How did Vermeer capture that light? How clever of Vermeer to have painted the officer with his back to us so we are continually guessing about the nature of his interaction with the girl. And the more I read, the more I understand the line of perspective that so brilliantly makes me feel I can literally jump into the scene. The touches of total realism lead me to a suspension of disbelief. The entire composition makes me feel like an outsider trying to listen in on what is going on at that table.

All of these questions stay with me, and I'm curious to learn more. I just want to go back and look at it again. And again.

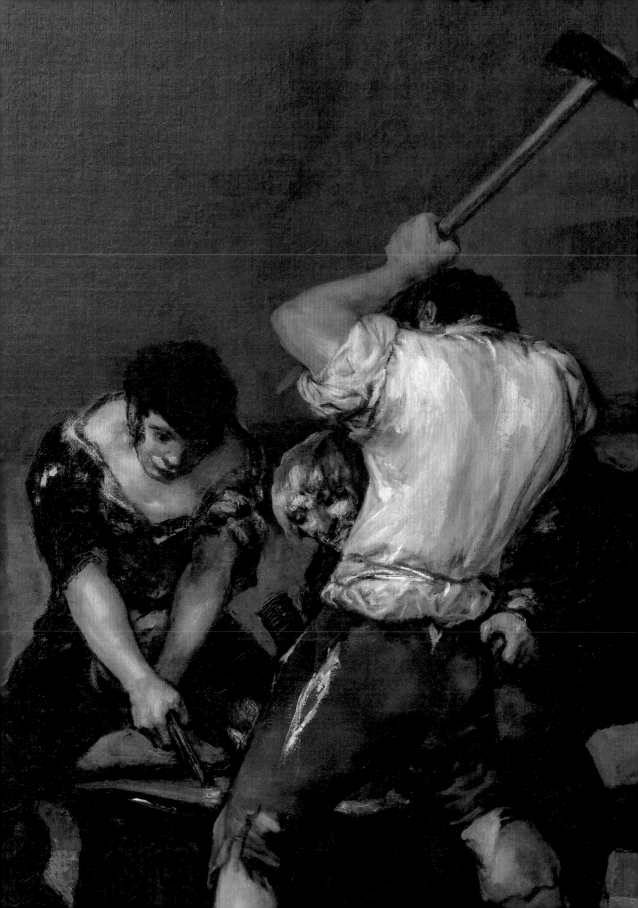

TOM BIANCHI

Francisco de Goya y Lucientes, *The Forge*, ca. 1815–20

In Goya's *Forge*, a blacksmith, a common laborer, is presented as a heroic figure. Holding a sledgehammer over his head, he is about to strike a red-hot plate on the anvil in an act of alchemy, transforming raw steel into a new useful form. The smith's assistants offer witness and aid to this danger-fraught exercise.

The Forge is an intensely modern painting, based as it is on a specific, near-photographic moment. We can believe this moment. These men are real—flesh-and-blood real. My own instincts draw me to the raw beauty and power of the man with the hammer in mid-strike. He is sturdy, broad-shouldered with a thick, muscled back and arms. Cinched tight at the waist, his shirt defines an idealized physique. He has a thick lower body and strong legs to support what one expects will be a powerful blow. We can hear the clang coming.

The symbolic meanings of the painting have been much discussed. Goya's sentiments were on the side of the common man against authoritarians. The etchings in his series *The Disasters of War* are among the most powerful indictments of the brutality of war ever made by an artist. Goya is known to have visited the battlefields of the French invasion of Spain and witnessed the carnage he so powerfully depicted in his work. The figure in *The Forge* is echoed in one of the *Disasters of War* series (plate 3, *Lo mismo*)—this time holding an axe aloft, about to behead a soldier he straddles. I note a detail that makes *The Forge* more poignant. The figure with the sledgehammer in *The Forge* and the figure in plate 3 both have a legging slipping down, revealing their left calf, adding erotic charge and human vulnerability.

As a whole, the art in The Frick Collection depicts the opulent wealth of European culture from the sixteenth through the eighteenth century. The presence of *The Forge* in the collection is an anomaly. Frick's fortune was built on the labor of steelworkers, whose union he infamously opposed. His reduction of the salaries of his workers resulted in the Homestead strike in 1892, in which seven striking workers and three guards were killed and scores more injured. Ultimately, Frick replaced the striking workers, mostly southern and eastern European immigrants, with African American workers, whom he paid a 20 percent lower wage. One wonders if Frick appreciated the irony of the inclusion of this painting among his Old Masters.

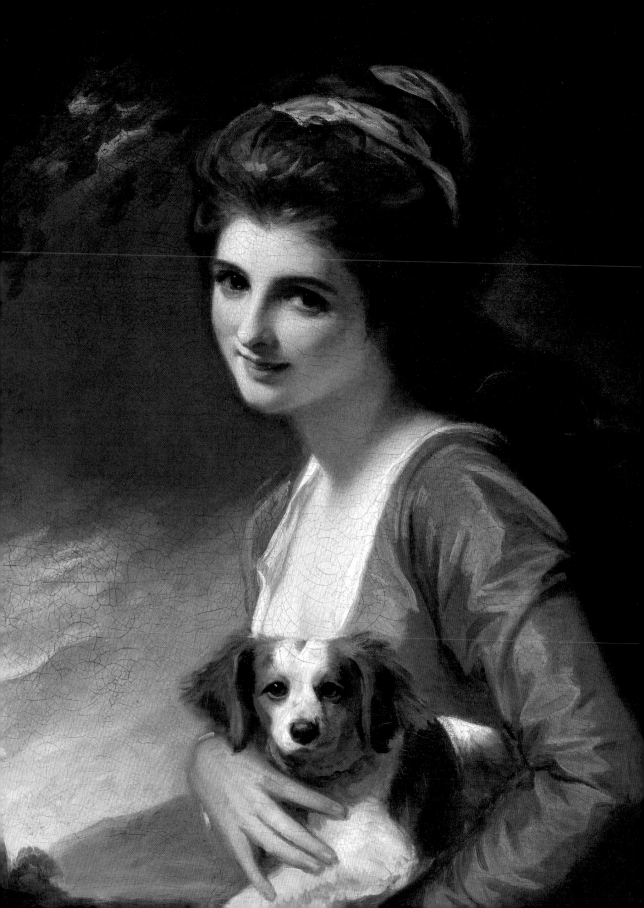

CARTER BREY

George Romney, *Lady Hamilton as "Nature,"* 1782

It was love at first sight.

At the end of a long winter afternoon perusing Titians, Whistlers, and Vermeers, I entered the last room, a tenebrous dark-paneled space wanly illuminated by the rays of the setting sun from across Fifth Avenue.

Over there, in that dark corner. I stopped and gaped. Who is that? A mysterious cord of attraction pulled me closer. I stood transfixed before an image of archetypal power.

Decades before, as a fourth-year German student, I had dutifully memorized the famous valedictory from part two of *Faust*: "Das Ewig-Weibliche zieht uns hinan" (The Eternal Feminine draws us onward). And now the phrase elbowed its way to the front row of my jostling thoughts. Yes. Here it is. The Eternal Feminine. It—she— had indeed pulled me onward into her ambit.

Created in 1782, the painting takes its place among the conventions of English portraiture of the time: the windswept, sketchily suggested bucolic background; the band in Emma's hair amplifying and continuing the colors and textures of the stormy skies; the faithful lapdog; the soubrette expression; the inclination of her head. The image borders dangerously on kitsch.

And yet.

All great portraiture exists on two levels: the image of the subject and the reaction of the artist to the subject. Whether intended or not, overt or covert, the artist's emotional response vibrates through the frame to animate our own perception.

Oh, how Romney's trembling desire broadcast itself through the medium of bold brushstrokes. He might just as well have cast a written declaration of love and lust upon the currents of time, to arrive at my feet two centuries later with undiminished potency and, yes, pathos. *Look upon her face as I did, and despair.*

Emma Hamilton sat before Romney's easel enough times for him to have produced dozens of portraits, each attempting desperately to discover the real Emma, to distill the essence of what he could only approach through his craft. A goddess. A spinstress. An allegory of Nature. It was no use; she slipped easily though his grasp to become the dream of other, more powerful men. She entered history. He succumbed to depression. And in a shadowed recess of The Frick Collection, she continues to draw us onward.

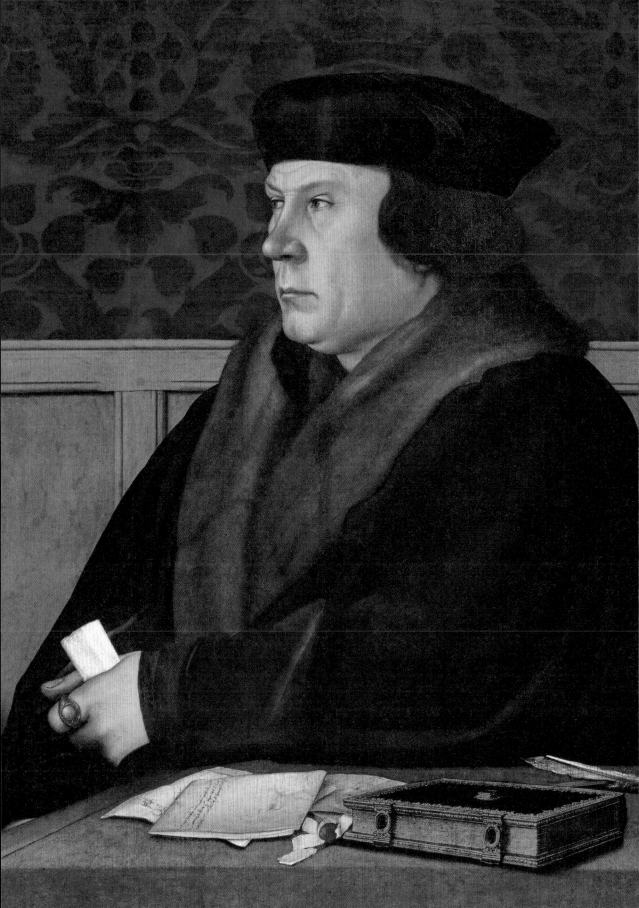

ROSANNE CASH

Hans Holbein the Younger, *Thomas Cromwell*, 1532–33

The first thing you notice is the gold ring on his left index finger. In the center is a cerulean blue stone, opaque but somehow also transparent, set in a luminous carved band. The blue in the stone speaks to the darker blue in the tapestry behind him: they are a visual diphthong. That's the first thing: you feel the bounce between the blues. Then, awareness spreads out to the four corners of the painting, past his hand, his robe, his desk, and the walls that close him in.

I once heard an art teacher say, in regard to a still-life painting of a bowl of fruit, "This is not a bowl of fruit. This is paint on canvas." But Thomas Cromwell is not just paint on canvas. Holbein has dipped his brush in alchemy. There are papers before him on his desk, which is covered in a velvety green cloth. The seal is broken on a document. A gold-and-black locked book, a quill, and what appears to be a small leather bag are artfully scattered on the table. He is clutching a piece of white paper between the index finger and thumb of his left hand. He is in his late forties, under tremendous pressure and in possession of tremendous power. He is the Chancellor of the Exchequer, Master of the Rolls, Principal Secretary, Master of the Jewel House, a dozen more titles and positions, and the chief confidant and counselor to Henry VIII. He is intelligent, cunning, well-fed, and sober. His rich black cloak, wide fur collar, and serious cap denote his status. One is visually warned that no one has the ear of the king without first going through Thomas Cromwell. It is seven years before he will be beheaded. It is three years after his wife and two young daughters die of the "sweating sickness." Although his expression is forbidding, our compassion is aroused, knowing what has—and will—happen. He is still grieving, and he must know his current abundance can't last. The king is violently impulsive and prone to turning on his courtiers. Cromwell will sit on the mountaintop of power until Henry destroys him. Perhaps Holbein senses it as well, because Cromwell's considerable figure is set in the middle distance of the portrait, not rendered in the foreground, where he could command and intimidate. He is removed with artistic calculation. It is like a chastisement or a slow, forced disappearance. The message of perspective is only one of many layers of emotion and prescience—both Cromwell's and Holbein's—that must be pulled apart, only to wind in on themselves again and again.

The Cromwell painting sits to the right of the Living Hall's lovely fireplace, and mirroring the great man on the left side is his friend, nemesis, and human harbinger of execution, Thomas More, also painted by Holbein. Cromwell looks toward More, but More looks away, into the distance. Locked in perpetual historical conflict and eternal contemporary proximity at the Frick, these two men tell a story that can be read in a blue ring, a broken seal, a fur collar, and an icy stare across carved marble in a magnificent Gilded Age drawing room. Their figures may be bonded in exquisite chromatic notes of blue, moss green, and black, but they are not just paint on canvas; they are the apotheosis of suffering, and they are residents of history and non-linear time. They are human beings with our same longing and loss, wrought by a master hand during a brief moment in a lost season of power and tranquility.

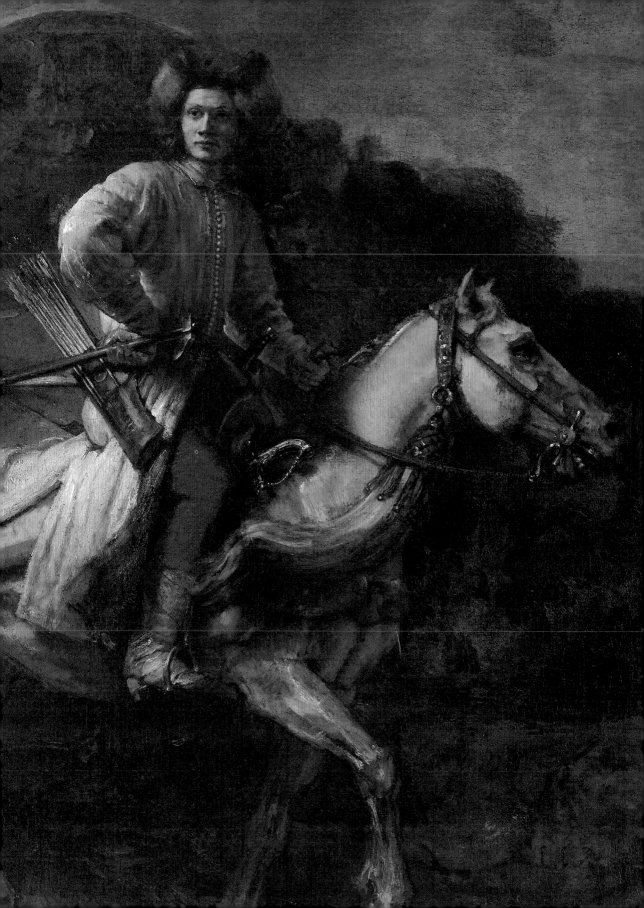

JEROME CHARYN

Rembrandt Harmensz. van Rijn, *The Polish Rider*, ca. 1655

I couldn't paint. I couldn't draw. But I was a fauvist—a captain of wild colors. Perhaps that is why I was accepted at Manhattan's illustrious High School of Music and Art in the fall of '51. The school had an abundance of girls and was hungry for male students, even a fauvist from the South Bronx.

Our first exercise was to visit a museum. I chose The Frick Collection since it sounded exotic and was located in a former mansion on Fifth Avenue. I was fourteen. I don't believe there was an entrance fee in 1951. Besides, I was a student, with a sketchpad to prove it. I remember a waterfall in the middle of the museum—no, it was a fountain . . . with the music of flowing water that reverberated off every wall. I went like a sleepwalker into the West Gallery, and my eyes instantly alighted on one painting—Rembrandt's *Polish Rider*. I marveled at the rider's relentless arrogance. He could have been a hoodlum from the South Bronx with his orange pants and orange crown.

He was looking away, indifferent to my gaze, beyond any sense of authority or ownership. He carried a quiver of arrows and an armory of other weapons; in his right hand, poised at his side, was some kind of hatchet, in a fist that curled outward in defiance. He looked Mongolian, this rider parading somewhere in the Polish steppe. He did not seem trapped within the painting but might, at any moment, ride right out of the frame on his battle horse . . .

It's difficult to convey my delight. He was untrammeled, my new Polish friend. I bonded with him right away yet couldn't claim him for myself. He was no one's property, not even Rembrandt's. Still, I left the Frick in a dream. I had found a mirror of my own wildness on Fifth Avenue, a piece of the Bronx steppe . . .

And now I return to the Frick, for the first time, after more than half a century. I'm wrong about the waterfall. The fountain is much less massive than I had remembered. You can't hear the sound of water from the West Gallery. Yet my rider is still there, just as defiant in his orange pants. How can I forget? With that curled fist, he encouraged my own desire to create.

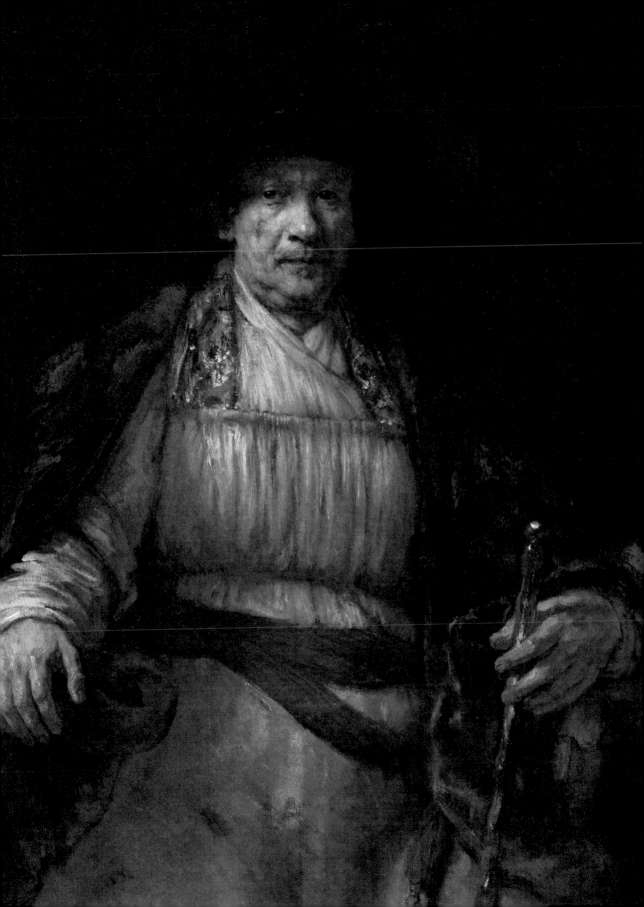

ROZ CHAST

Rembrandt Harmensz. van Rijn, *Self-Portrait*, 1658

The Frick is one of my favorite museums in New York. It's not too big, and almost all the paintings and objects are not only interesting but also iconic. When one walks around, one asks oneself: Am I really looking at the actual Ingres painting of Comtesse d'Haussonville, with that incredible pale blue satin dress and that weird right arm, and not just a facsimile? Am I witnessing, with eyes that minutes ago were staring mindlessly at an ad on the subway, this Holbein painting of Sir Thomas More? How is it possible that I am standing in front of an actual Vermeer?!? Oh my God. There's Manet. There's Constable. I hope I don't make a fool of myself in front of this Bellini. It's like being in a magnificent house filled with art celebrities.

I thought of writing about the Bronzino painting of Lodovico Capponi, which fascinated me when I was a teenager, even though Lodovico looked like a sneery, snobby person. And also, what was with that codpiece? I considered writing about that Nevers blue oval platter with the yellow flowers that would look really great in my apartment, should the Frick someday decide they were tired of it and were looking for someone who would give it a loving home. But a couple of weeks ago, I was walking through the room with the Rembrandt self-portrait, the one he painted when he was fifty-two. It literally stopped me in my tracks. He's wearing a big floppy black hat and a cloak of maybe fur or velvet. Under that, he is wearing a golden-yellow billowy tunic. The whole outfit is tied together with a red sash. It's very theatrical. It's a costume. But it was his face that mesmerized me. I felt his self-awareness. He knew of his power as an artist and also of his frailty and his mortality. This communication felt so real that, for a second, I felt as if I might cry. You don't have to tell me how cheesy that sounds because I know. I kept standing there and looking at it. I felt as if he were saying to me: Once I was alive, like you. Sometimes I suffered. Sometimes things seemed funny, or maybe absurd, especially myself. I was a man. I was an artist. I was a great artist. My name was Rembrandt Harmensz. van Rijn. I painted this painting. I lived. I died. Yet here I am. There you are. We are looking at each other.

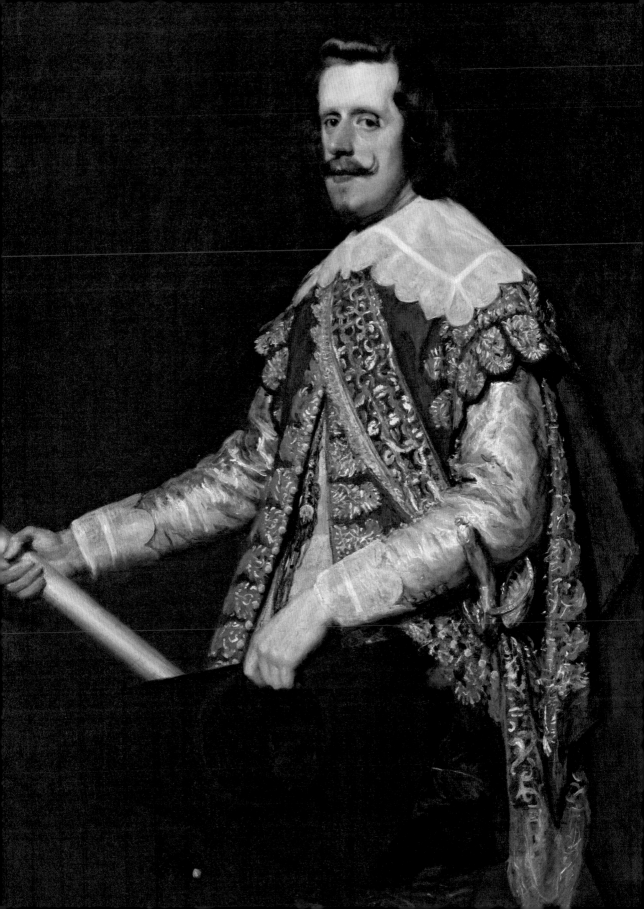

GEORGE CONDO

Diego Rodríguez de Silva y Velázquez, *King Philip IV of Spain*, 1644

Facing you when you walk into the West Gallery of the Frick is the Velázquez portrait of Philip IV. His eyes fixed upon you, but not me, he looks beyond us from another dimension of time, as he himself has been made time-less by Velázquez. "How did he do it?" I ask myself as I stare at the silver, vermillion, and black, at Philip's head placed carefully atop lace, his see-through hat and brocaded cape. My mind assembles the brushstrokes into perfect patterns that suggest blue poles, like the Pollock painting of that name. He's got a pole too. There's a majestic presence here; yet it's all just paint. This illusion, this delicate transparency and choice of color, requires the skill of a master. I don't mean the pink and silver; I mean the variant tonalities of the blacks in the hat—the alternation of blue-black and brown-black and the way they create depth in the picture plane, the seemingly simplistic use of a very few colors, with the eccentric curl of hair reflecting a light that both glorifies and defines its beautiful glow. Again, the perfect mix of color. The shadow of a mustache on a cheek. Eyes that are cast downward but still let us look at "him"—not repelling our gaze as we study him.

Velázquez wants us to see his painting as much as he wants us to see its subject. They are metaphysically interchangeable. My impression is one of wonder. How powerless is this king without his master Velázquez. If Velázquez hadn't been such a great artist, who, other than a historian of past royal dynasties, would care? It's not history to me; it's paint and what you can do with it—light, shadows, and technical virtuosity, mastery of material to get the most out of the least. Velázquez has created a solid illusion. The depth of his skill as a painter dominates the content of every painting he has ever made

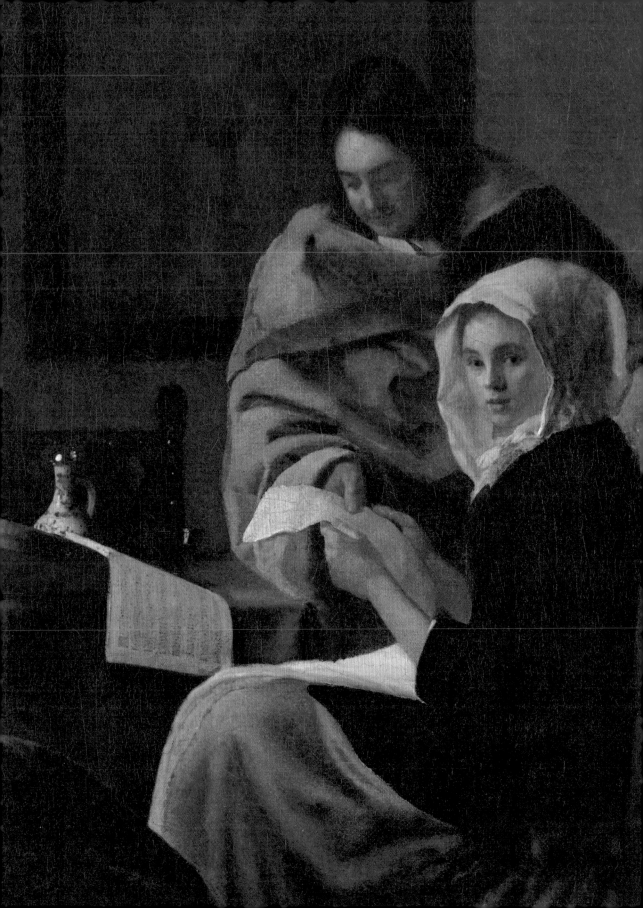

GREGORY CREWDSON

Johannes Vermeer, *Girl Interrupted at Her Music,* **ca. 1658–59**

Int. 17th-Century Study—Late Afternoon We are peering from shadows into a windowed corner of a quiet,
patrician study. Elegant and sparse trappings suggest seventeenth-century Europe. A small table draped with
fine cloth sits at the center of frame, encircled by three ornate upholstered wooden chairs. The window, to our
left, spills light across the table and just over its edges; stained glass casts the primary exterior light source as
a diffuse warm glow.

Sheets of music, a wine decanter, and a glass of red wine are among other objects on top of the table. A
painting, almost indiscernible in the shadows, hangs on the opposing wall, facing us.

There are two figures at the table, awash in the beautiful light. A MAN stands toward us; his face in three-
quarter view. He has a downward, contemplative gaze and is slightly bent toward a YOUNG WOMAN, who is
seated beside him in a chair. They're both dressed in fine silks and linens in pale blue, except for the woman's
coat, which is the color of red wine. Their hands intimately clutch either side of a sheet of music. Meanwhile, the
woman glances over her shoulder, vacantly, in our direction, with an air of curiosity and expectation.

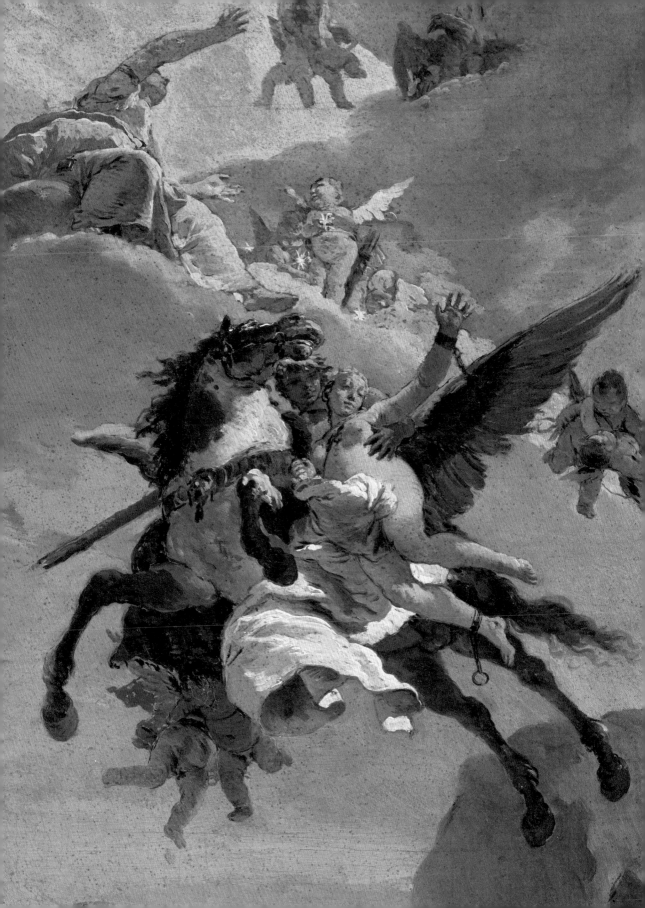

JOAN K. DAVIDSON

Giambattista Tiepolo, *Perseus and Andromeda*, ca. 1730–31

Entering the Frick, the visitor tends to head to the galleries where the Fragonards, Titians, El Greco, the great Holbeins, and other Frick Top Treasures are to be found. Or, perhaps, you turn left to the splendid English portraits in the Dining Room.

But not so fast, please. You could miss my special picture!

My picture is small in size and hangs modestly and rather high on a side wall of the corridor, before those right or left turns, and is easy to overlook. It is made even more overlookable by the view of Central Park that rises alluringly at the end of the corridor.

It's a marvelous work by Giambattista Tiepolo, the great Venetian artist of the late eighteenth century. Called *Perseus and Andromeda*, the painting is a study for the vast ceiling the artist created for a palazzo in Milan (which was bombed in 1943).

I love this perfect work of art for its luscious color, its draftsmanship, its energy, and its ambition. And I love it because—in the Frick's mighty collection of serious, even solemn still lifes; no-nonsense portraits of dignitaries; and sometimes bleak landscapes and seascapes—the Tiepolo seems to offer up a vision of freedom and joy.

I also love this painting because of its intimate, fond connection to my family. My mother, Alice M. Kaplan, had a very personal collection of paintings, sculpture, drawings, textiles, objects, and books, from many periods and cultures, that she had accumulated during a long life. And her own prize was a magnificent drawing by Giambattista Tiepolo. She also, happily, owned two drawings by Tiepolo's son Domenico, a brilliant artist as well.

In my fuzzy memory, I see fading, torn Tiepolo postcards (both father and son) stuck in mirrors, or on the fridge, in every house we ever lived in.

Three cheers for Tiepolos (both), and for the Frick!

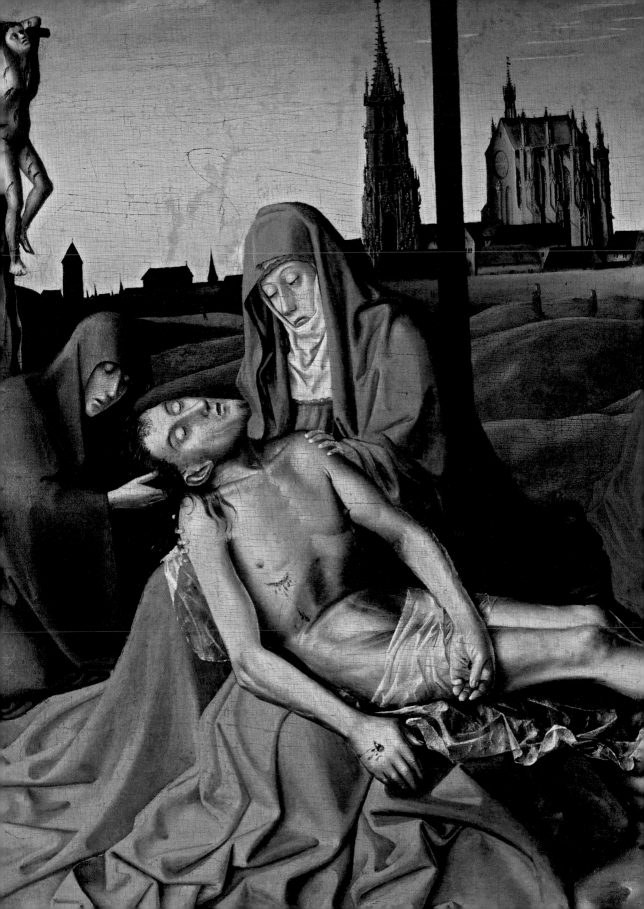

LYDIA DAVIS

Circle of Konrad Witz, *Pietà*, ca. 1440

I first visited the Frick when I was a child—although, by the rules, ten or older. Because of the reliable perma- nence of the collection—the paintings usually hanging where I knew to find them—they became engraved in my memory. Over time, of course, I changed, so my experience of the paintings also changed. The beauty of a collection such as the Frick's is twofold. For a first-time visitor, the works on view present a novel experience and are appreciated as such. For the returning visitor, the experience is perhaps even better: one looks at a painting more deeply and in more detail and discovers, on each visit, a previously unobserved aspect so that the painting, too, changes over time.

Over the years, I have always returned to Holbein's commanding portrait of Thomas Cromwell; the muscular intensity, dynamism, and perfect balance of Goya's *Forge*; and Bellini's *St. Francis in the Desert*, which continues to reveal itself to me—I now no longer examine the saint so much as the massive rock face that, curiously, fills most of the canvas. I follow the winding roads in the paintings of Hobbema; but I have recently become magnetized by the startlingly straight road that leads from the viewer up the middle of Rousseau's *The Village of Becquigny*, with its houses huddled on either side, some with thatched roofs that reach nearly to the ground, houses made from elements of the landscape and destined, with perfect economy, to be reabsorbed into the land.

Today, the painting I study with such pleasure is one I have not known as well, a Pietà by an artist in the circle of Konrad Witz. It is the angularity of the central Christ figure that first strikes me, close in the foreground, so stiffly jointed, the awkward hardness of the limbs reminding me of an artist's wooden figure, its pallor chilly even against the luscious river of Mary's silver robes. Mary, with her grim, metallic features, is flanked by two women hooded and robed in subtly different reds—their ashen flesh is hidden but for a bit of the face of one, and the face and a hand of the other. In the middle ground, two realistically rendered, contorted bodies hang from the second and third crosses, yet, oddly, the hilly terrain below and behind them is purely unnatural, with its evenly green mounds devoid of any growing thing and punctuated by tiny, lone figures in the far distance, also unnatural in that they are unaccompanied by any signifiers of everyday activity—no baskets, bundles, donkeys, carts, or little children . . . Finally, drawing my eye deep into the perspective, in a level line across the far background, the pristine, crystalline walled city extends from one side of the canvas nearly to the other. My pleasure is not only in the colors and textures of the work, and the equipoise of the foreground figures, but in the clarity of each level of the painting, the distinctness with which my gaze can move from fore- to middle- to background, as though from present to recent past to distant past, or even from immediately unfolding action to recently completed action to the eternally repeated everyday.

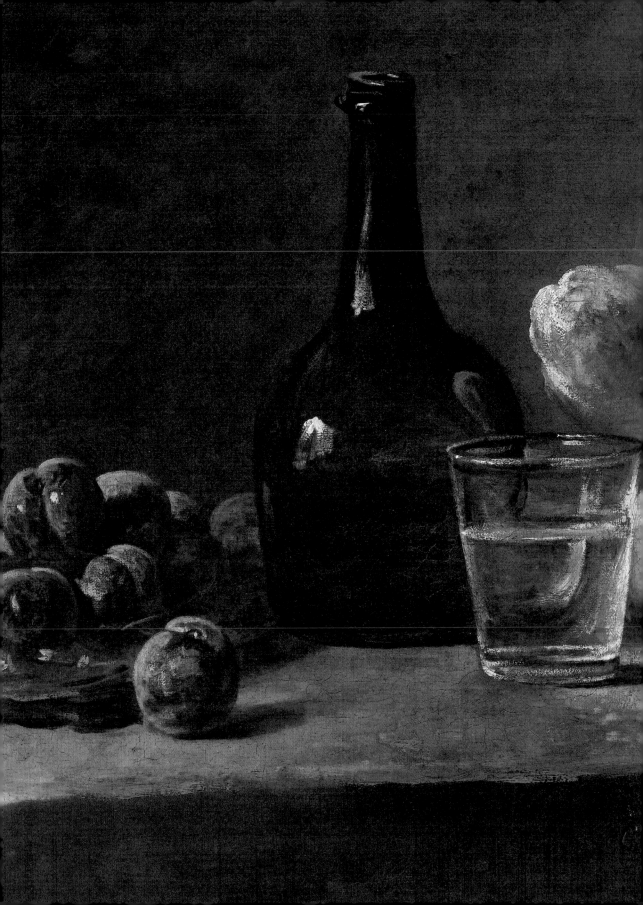

EDMUND DE WAAL

Jean-Siméon Chardin, *Still Life with Plums*, ca. 1730

Put the glass of water on the shelf. Move the bowl of plums, the carafe.

Move away.

It is September, and the stall at the end of the road on the way home from the studio has plums. They are from Worcestershire, she says, Victorias, bruisable, the sheen a smudge of late summer. She waves away the wasps and fills a brown paper bag full of sweetness and decay, last songs. Their purple is melancholic.

Take them home.

This is just to say that I cannot look at plums and not think of Chardin.

Proust loved Chardin. He cared about the settling of disorder and chance into image. He called it "the life of still life." It is a useful phrase, returning us to the way that you move things round, move words around, to get to a place where the images pulse with balance and power. If you get it right, the cadences keep going.

Chardin paints this act of moving things around, that adjustment of the world to make some shadows work harder, find a "delight in disorder," a "wilde civility" (to borrow from Robert Herrick). He puts a little porcelain on a table. The shuffle between warm teapot and slop basin and teacups, sugar basin and milk jug, the small sounds of liquid, the glints of silver and bright linen make the porcelain seem even whiter. Chardin is very good at porcelain. He loves his Vincennes coffeepot.

Chardin paints *A Bowl of Plums*. He then paints *Still Life with Plums*. Then *Basket of Plums and Glass of Water*. Then *Basket of Plums*.

You have to pay attention. Some of the plums are purple, some are green Mirabelles. The glass of water looks the same, I think, in most of his pictures, but the bloom on each plum is evanescent and immortal.

> I have eaten
> the plums
> that were in
> the icebox
>
> and which
> you were probably
> saving
> for breakfast
>
> Forgive me
> they were delicious
> so sweet
> and so cold

WILLIAM CARLOS WILLIAMS, "THIS IS JUST TO SAY," 1934

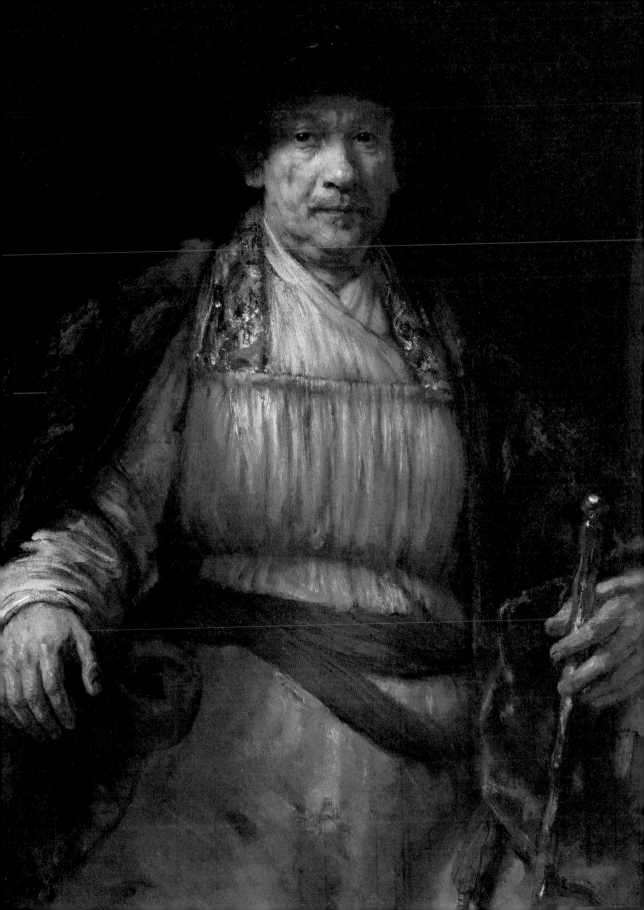

RINEKE DIJKSTRA

Rembrandt Harmensz. van Rijn, *Self-Portrait*, 1658

Rembrandt's *Self-Portrait* at the Frick is one of the most afflicted among the many self-portraits this artist produced. It dates from 1658, a turbulent year for him. Two years earlier, he was declared bankrupt; consequently, a large part of his estate, including his treasured collection of art and other objects, was sold at auction—for less than he had anticipated. In 1658, Rembrandt, together with his beloved Hendrickje and his son, Titus, is compelled to vacate his house. Once lauded as the greatest painter of Holland, he now hits rock bottom, surpassed in popularity by younger colleagues apparently better equipped to answer the demands of modern taste.

Rembrandt's response? He creates this portrait, depicting himself as a king, a monarch, a ruler: with staff at hand and dressed in a gold-colored garment, his seated figure fills the chair. It could not be more contrary to his personal circumstances. But the visible manifestation of that tension is what makes it so interesting. Rembrandt does not conceal his struggle: the clothes and staff may seem imposing, but the fleshiness of his face and its forlorn gaze are that of an older man, hardened but simultaneously tormented and hurt. It is as if Rembrandt compressed his entire life up to that moment into this one portrait.

When I began my series of beach portraits, and later my *Mothers* and *Bullfighters*, I was intrigued by the different, complex, and sometimes conflicting emotions simultaneously manifesting themselves in my subjects, wondering whether they could be captured in a single image. People are never one-dimensional; they are dealing with a variety of things at any given moment. In this complexity, which is difficult to grasp, the intensity of a moment becomes visible—the impression of someone being alive. I always hope that when you look at my photographs, you feel you have met someone. That is why I try to determine a person's individual traits. I soon realized that these are best highlighted when a number of elements are combined: posture, expression, shape, light, and details. The challenge is to prevent the overall result from becoming stiff. There must be some movement, as well as a certain casualness.

When, later on, I familiarized myself with the work of Rembrandt, I recognized that he used many similar techniques, albeit in paint (which, of course, is much more admirable). It almost seems as if Rembrandt is looking for that photographic moment, exactly because he emphasizes the inner turmoil of his subjects. In his portraits, everything seems to be in flux: the gaze, the light, the colors. He sometimes works through details of hands and costume with great precision, while at other times he deliberately remains vague, giving a mere impression or indication. But all elements propel each other forward, and, in the portraits, they effortlessly come together in such a forceful yet natural way that one does not question that this is exactly how these sitters should be depicted.

That is what makes the emotions evoked in Rembrandt's paintings seem so intense, so real, and what makes his *Self-Portrait* at the Frick so special. Again, Rembrandt achieves a great intensity, but, in this case, he uses it for some unrivalled introspection. Look at him, sitting there, the former king—still strong, yet seemingly dethroned. But wait, is he? One need only to look at this painting to realize that Rembrandt is still the best, that nobody sees things the way he does, that he knows how to ruthlessly analyze his subjects—even himself. No one is better at it. Not then, not now.

TRANSLATED FROM THE DUTCH BY ROZEMARIJN LANDSMAN

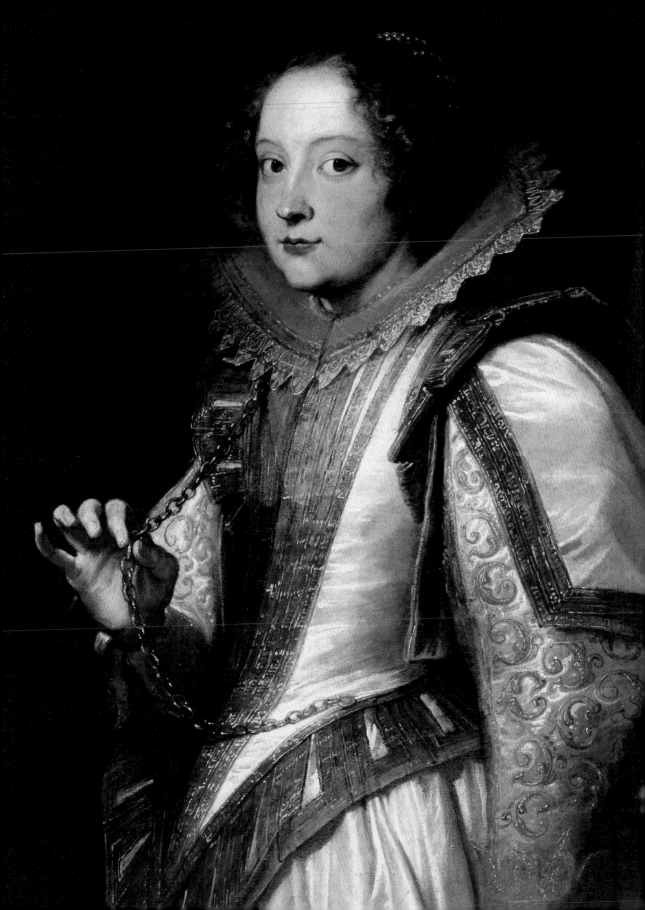

MARK DOTY

Anthony van Dyck, *Marchesa Giovanna Cattaneo*, 1622–27

The motion, the energy with which she entered the frame barely arrested. Nothing about her of stasis, no sign of a willingness, even briefly, to stop paying attention, to cease consideration of what's before her. She hasn't come to be looked at, and if she has, this will in no way limit her looking back. Imagine, being content merely to be gazed upon!

Her gaze brims with curiosity and intelligence as she studies him studying her—to see if she can read in his look something of how he sees her? Is she perhaps attracted to him, as she might be indicating through that fraction of a smile?

How can he work, how focus with that inquiring presence before him, a woman who makes those in other portraits seem on the verge of sleep, possessed by being looked at, barely concerned with their own seeing? How, under this pressure, that lively mind, its frisson of humor, can he work, how produce a rendering so steady and exact? The architectural tilt of her collar, a lace valentine floating on darkness, that he can perfect alone, in the studio. But her superb right hand, alive and individuated as every bit of her face—that he must do while she holds it in the air, just so, thumb and forefinger pressed against a single loop in the golden chain that seems to measure, precisely, the degree of time she will allot to him.

And, though I suppose she did not think of this, just the degree of time she will devote to us, before she turns and walks on along that dark brown corridor, a little wind from her passing still lifting the white silk cape attached to her dress at the shoulders.

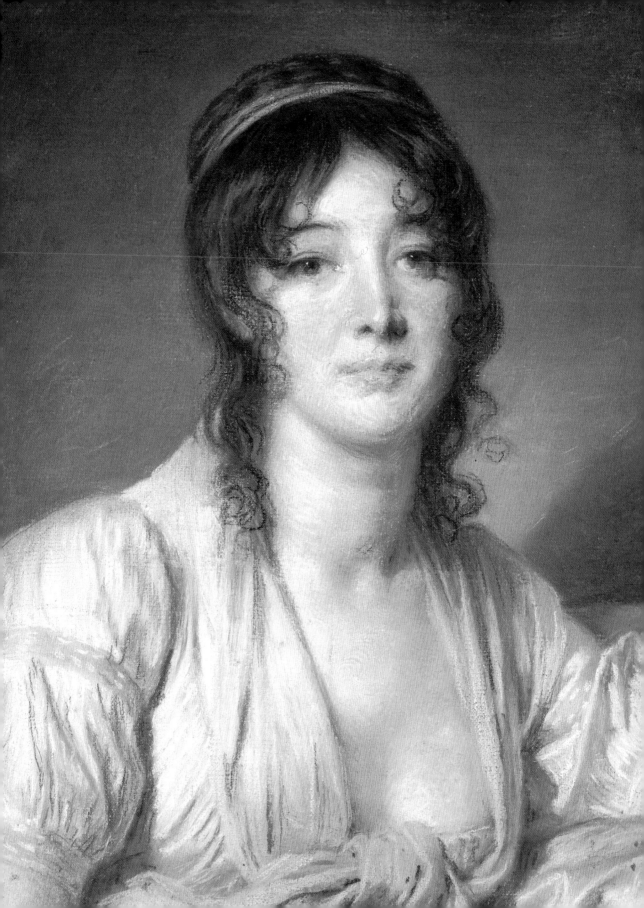

LENA DUNHAM

Jean-Baptiste Greuze, *Madame Baptiste aîné*, ca. 1790

Madame Baptiste *aîné* is drawn in "pastel on cream paper," a combination that makes it nearly impossible to remember that she has a face. In the Frick's *Handbook of Paintings*, the commentary for Greuze's portrait of the little-known wife of a celebrated male actor (they're all actresses, darling) tells us that after a promising start on the stage, Madame Baptiste received roles of less and less import. You see, "She had a terrible fault, which consisted of not allowing to be heard a single verse that she delivered."

Maybe, dear writer of The Frick Collection notes (which are detailed and wonderful and deserve no ill will, especially not from a woman currently failing to accurately count the days since she last showered), Madame Baptiste was simply tired. Maybe, as she sat—bosom forward—watching fourteen kinds of pastels blur into a creamy mask of her former self, she wondered, "What's the fucking point?"

She spoke loudly onstage once. She belted her iambic pentameter to the rafters—yarn merchants heaving with gold and jolly whores alike laughed and, ultimately, cried at the beauty of what she could do. But time gives to some of us and takes something from a lot of us too, and she found herself rasping over dinner as she told her boys to settle down and coughing as she dusted the endless curtains and gasping as she watched her husband pinch the high pink cheeks of the laundress and kiss the lower, pinker ones of the girl backstage.

In her portrait, Madame Baptiste purses her lips as if she's waiting for a cup of water to swallow the vitamins she's squirreling away in her cheek. Her bangs frame her face in the fashion of a woman selling vintage at the Brooklyn Flea, her hemp overalls for sale in her Etsy shop. She's doing oatmeal monochrome like an Olsen twin at a Hamptons christening. But she's tired, and so she delivers her short and pointless monologues in an aching whisper.

Ten years ago, I went to San Francisco, breaking the five-hundred-dollar limit on my first credit card so I could kiss on the trolley and eat ravioli in bed and snort Adderall off of Nan Goldin books. The boy I was visiting took a Polaroid of me in bed (oatmeal dress, oatmeal skin, greasy hair), and he watched as it developed, saying, "Look, she's a Renaissance maid!" I believed him, there in my nightgown. And I believed our love, and my body, would always be this strong and this good and that nobody forgets about strong and good things. I wasn't right and I wasn't wrong, but I also imagined people would keep their word and reality wouldn't be a fight. I would look, every morning, like I had when I was freshly in love and caught on Polaroid. We all know how that goes. Especially Greuze. Especially Madame Baptiste.

If I were being drawn in pastels by Greuze, I probably wouldn't have the heart to interrupt and demand that my features be divisible from each other and my dress just a little less sheer, you know, to reflect the reality of being a working mother. I wouldn't even say, "Hey, I'm not that sad, Greuze—lighten up that smile!" I'd just purse my lips and nod my head, and that night, when my husband dragged me onstage at the Théâtre de la République just to prove we were still the dream in action, well I, too, would whisper.

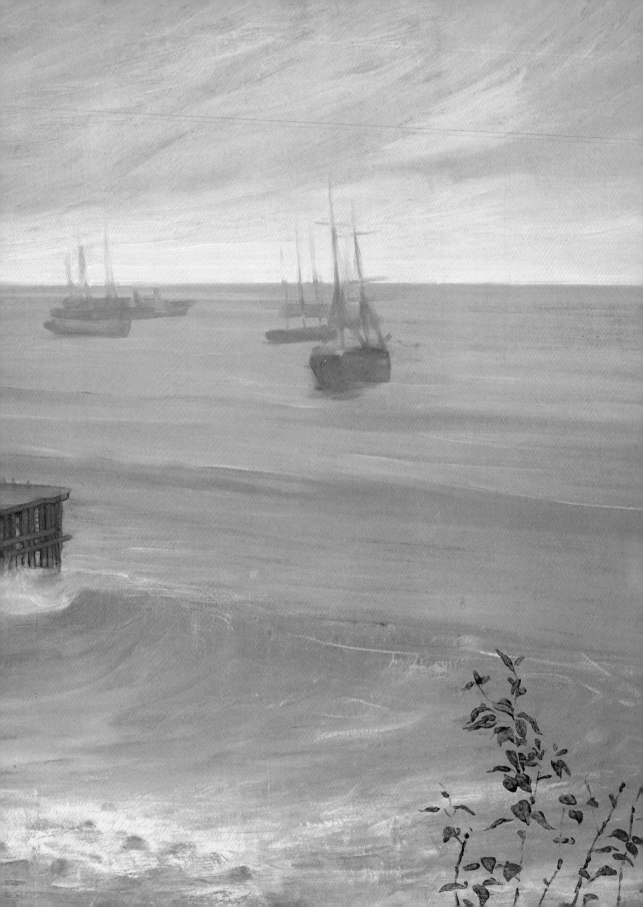

STEPHEN ELLCOCK

James McNeill Whistler, *Symphony in Grey and Green: The Ocean*, 1866

For much of my early childhood, I lived a few hundred yards from a leaden sea that was the color of catarrh. I lived in a landscape of saltwater creeks and mournful marshes, of wharves, jetties, runnels, and rivulets, of windswept foreshores pocked with spikey beach-grass and booby-trapped with broken glass.

I was raised on tales of wayward infants coming to their ends on treacherous mudflats; of customs men and contraband; of gibbets erected on lonely headlands to deter pirates, wreckers, and mutineers; of marauding Norsemen and colonizing Angles, Saxons, and Jutes (as well as the occasional opportunist Geat); of endless battles with surging tides and deadly floods; of Witchfinder Generals and sunken towns and tolling underwater bells.

Even then, during a time of supposed economic plenty, the place seemed a beaten-down backwater, saturated with the same understated melancholia as a ghost story by M. R. or Henry James, but it was also a place of mystery and enchantment where a child's imagination had the freedom to roam under vast, unfathomable skies and zigzag between impossibly distant horizons—providing the perfect backdrop for decades' worth of pipe dreams. It was also the place where a lifelong love of print, word, and image was forged.

Whistler created *Symphony in Gray and Green: The Ocean* during a visit to Valparaíso, Chile. This monochromatic ocean on the other side of the world from the North Sea of my childhood has always seemed eerily familiar. Whistler effortlessly captures the power roiling away beneath the ocean's serene surface, the elision of sea and horizon, and the pathos of unmanned ships in harbor.

But what really distinguishes this painting from a thousand other nineteenth-century seascapes are the somewhat incongruous foliage and the rectangular cartouche bearing Whistler's monogram in the shape of a butterfly in the lower right of the picture. These decorative elements represent a riposte to realism and washed-out convention, an intrusion of artifice and inscrutability subverting the clichés of an ever-popular genre.

Among my few childhood mementoes—a shelf's worth of tattered books, a handful of snapshots, and little else—one black-and-white photograph has always seemed more precious than others. It is an image of me as a dyspeptic-looking baby, sitting upon an apparently deserted stony beach, my gaze fixed, not upon the photographer but on the sea beyond. I am chewing intently on some kind of toy or pacifier resembling a large, rectangular cookie or cartouche. Occasionally, I like to imagine that if I were to magnify the photo and stare at the plastic rectangle for long enough, I might just discern the faintest outline of a butterfly-shaped monogram.

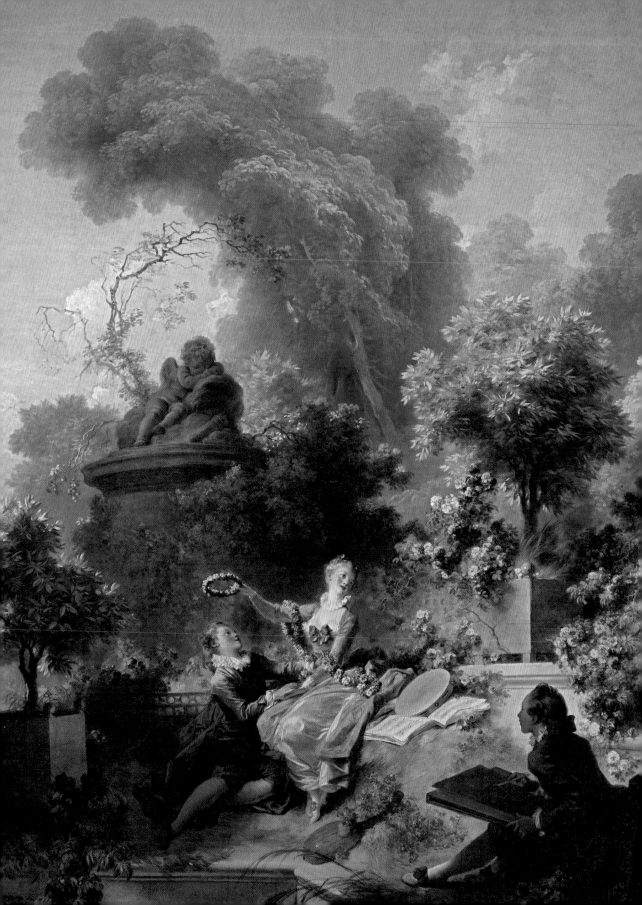

DONALD FAGEN

Jean-Honoré Fragonard, *The Progress of Love* (*The Pursuit*, *The Meeting*, *The Lover Crowned*, and *Love Letters*), 1771–72

Fragonard's Dream In the late '80s, as a long romance was beginning its last excruciating phase, I'd often spend the afternoon sitting in the Garden Court of The Frick Collection. The Engelhard Court at the Met was closer to my apartment, but the Garden Court was smaller and cozier, just right for an extravagant sulk.

Wandering through the galleries one day, I found myself in the Fragonard Room, a beautiful space dedicated to the series of paintings known as *The Progress of Love*.

I have zero academic knowledge of the visual arts, but, standing in the Fragonard Room in front of those four huge panels, one doesn't need to have been an art major to feel the effect. It's like being blown away by a French love bomb.

The four original paintings were commissioned by Louis XV's mistress Madame du Barry to decorate a salon in her new "pleasure pavilion" near Versailles. The panels depict the "ages of love." All four scenes—*The Pursuit*, *The Meeting*, *The Lover Crowned*, and *Love Letters*—take place in a garden alive with dense, verdant foliage and upthrusting trees.

Gazing at the luminous eighteenth-century panels, I couldn't help comparing these romantic visions of perfect love with the "progress of love" as it usually unfolds in the real world: the feverish rush of desire, the euphoric first months when lovers are compelled to idealize each other, followed by the inevitable crash when the levels of serotonin, oxytocin, and dopamine in the brain start to plunge.

During my first year at college in upstate New York, I was smitten by a slender blonde elf of a girl. Nora (I've changed the name) had the sort of flicker and glow that can only be the product of a chaotic, troubled childhood. At nineteen, she was gorgeous, darkly funny, a natural prodigy at the piano, and generally too cool for school. I trailed after her like an injured puppy until, out of pity, she let me spend one night in her room. The next day, when her off-and-on boyfriend arrived on campus—a dope-dealing dirt bag from New Paltz—my moment of bliss was over. I was crushed.

It gets a lot worse. Fast-forward about fifty years. Thumbing through the *New York Post*, I happened to see an article about a white-haired purse-snatcher. And there she was, my Nora, or the latest avatar of Nora: a stealth-eyed little old lady, caught on a restaurant's CCTV. I thought that maybe I should do something, but, a few days later, I read that she had died.

Nature—and human nature—rarely plays out as it does in Fragonard's panels. Still, who would give up those moments, the rapturous dreams that make life worth living? And what's so great about reality anyway? Fragonard's mentor François Boucher said it as well as anyone: "Nature is too green and badly lit."

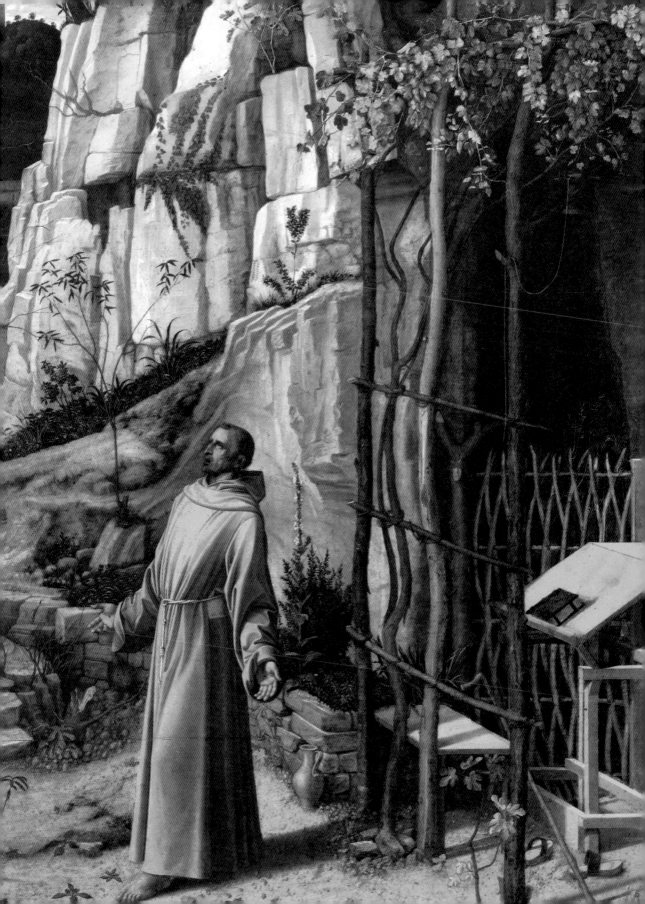

RACHEL FEINSTEIN AND JOHN CURRIN

Giovanni Bellini, *St. Francis in the Desert*, ca. 1476–78

Looking at a painting over and over again never gets old, especially when you can do so together as two artists. Each time, we notice something different, and with two sets of discerning eyes, there is more to see, especially with Bellini's *St. Francis in the Desert*, which we first saw many years ago. Looking at the painting is like a game; each time, some new visual clue is revealed—like the waterspout on the bottom far left under the rocks, spotted only recently. There are so many little gems scattered throughout the painting.

Rachel: It was the strange malachite green rocks that initially caught my eye. They make me think of Mordor in *The Lord of the Rings*. The mythical rocks, their weird structure and odd shapes, could be the setting for a dark fairy tale and remind me of the rocks on the Led Zeppelin *Houses of the Holy* album cover. I always wonder why the rocks are that strange green color. John says Bellini might have used a glaze on top of that bottom layer of green or that the original color simply turned another shade with age. Either way, the original color is now long gone. This makes me think about Greek and Roman sculptures—how their stark whiteness has become part of their everlasting beauty even though they were originally garishly painted by their creators. I've always been interested in how beauty and meaning change with the times, and the malachite green rocks in Bellini's *St. Francis* first spoke to me for this reason. Like a reread book, a painting seen at a later period of your life is not the same painting. The significance or interpretation changes with the viewer.

John: The details of the leaves, little weeds, and sticks coming up through the rocks are what I love most in this painting. It's as if Bellini, through those sharp leaves, is showing the clarity you feel from being an ascetic monk living alone in a cave.

Rachel: That moment of isolation is fascinating in the context of the situation we are in now because of COVID-19. Our family of five may not be living alone in a cave right now, but due to the current circumstances, we have turned more inward, like St. Francis. Looking at this image and its sharp clarity during this time of fear and uncertainty is very soothing and inspirational.

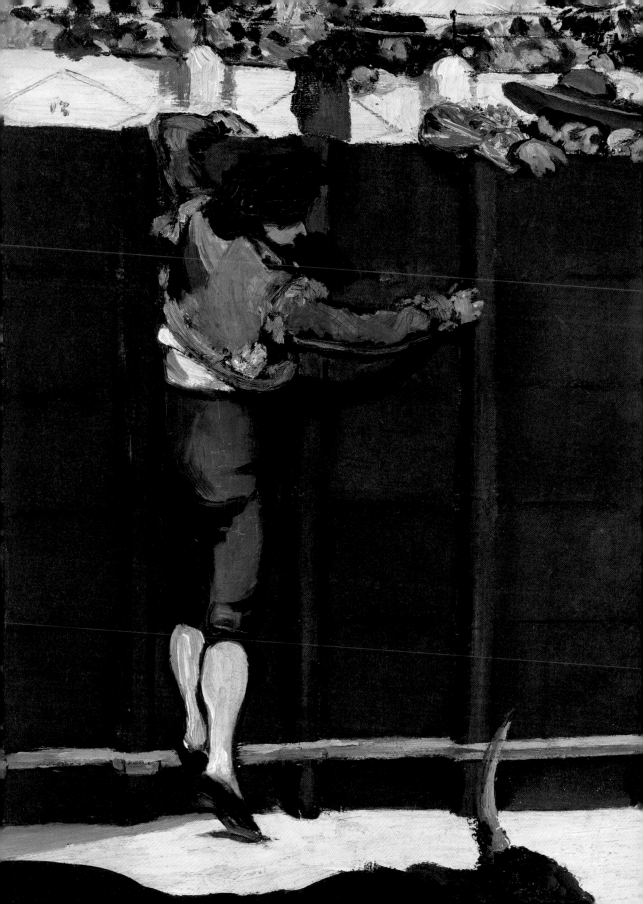

TERESITA FERNÁNDEZ

Édouard Manet, *The Bullfight*, 1864

> One of the most beautiful, most curious and most terrible spectacles one can see is the bull hunt …
> I hope to put on canvas the brilliant, flickering, and at the same time dramatic appearance of the
> corrida I attended.
>
> MANET TO BAUDELAIRE, SEPTEMBER 14, 1865

Being in More Than One Place at a Time: Manet's *Bullfight* In 1864, Manet exhibited a large painting called *Episode from a Bullfight* at the Paris Salon. It was received with harsh criticism, the press mocking the image of the fallen matador as grossly out of proportion to the bull that had just gored him and as lacking relief and a convincing depiction of space. One can only imagine the sting of this rejection churning in Manet, keeping him up at night and fueling a need to redeem himself and his painting, which was also largely thought to be blatantly inspired by (or copied from) a seventeenth-century masterpiece by Velázquez called *The Dead Soldier*, reproduced as a large photograph a year before.

Perhaps in reaction to this blow to his ego, Manet cut two sections out of *Episode from a Bullfight* and developed each of them into an independent painting, re-working the backgrounds, extracting the dead matador entirely from the surrounding context of the bullfight, and discarding the rest of the canvas as scraps.

Today, one painting is in New York at the Frick (*The Bullfight*) and the other is in Washington at the National Gallery (*The Dead Toreador*). I like to think of these two paintings as conjoined twins, separated at birth but nevertheless perpetually destined to be understood in the context of each other, two distinct images utterly wrapped up in each other. Manet's *Bullfight* has always fascinated me as both an example of the replenishing act of destroying and generating images in one's studio practice and as a radical exercise in imagining. Both of these forms of engagement are rooted in the fact that the act of seeing images flickering in the mind's eye often has less to do with the optical factualness of vision than with a performative act of imagining, dreaming, reinventing, and reconstructing what is no longer in front of one's eyes.

In many ways, Manet's almost surgical act of repair and reconstruction was an urgent attempt to redeem the painting, a way of pushing the work to the extreme in order to salvage it and invent something that could be more than the sum of its parts—a something from nothing. This creative act, which epitomizes the fragility and resilience of being an artist, the idea of not being able to fool oneself in the intimacy and privacy of the studio, seems entirely familiar. The creative act always happens both publicly and privately, validated externally, by viewers, and internally, by the wordless witnessing of oneself in the act of thinking and making.

These acts on Manet's part pose a richly layered conundrum for contemporary viewers engaged in the act of looking, as though at any given moment one is in more than one place at a time, always imagining the other half of the original painting. When I stand in front of *The Bullfight* at the Frick, I am transported to Washington,

conjuring up *The Dead Toreador* and imagining it reunited with *The Bullfight*, a kind of simultaneous image-layering constructed in the intimacy of a private, floating, and invented museum space in my own mind. In this way, we are implicated in Manet's creative dance, the act of fracturing, imagining, and reconstructing "the brilliant, flickering, and at the same time dramatic appearance of the corrida"—which lives in the saccadic efforts of the eye to find meaning and make images precisely in the pauses, blinking and flickering between seeing and not seeing.

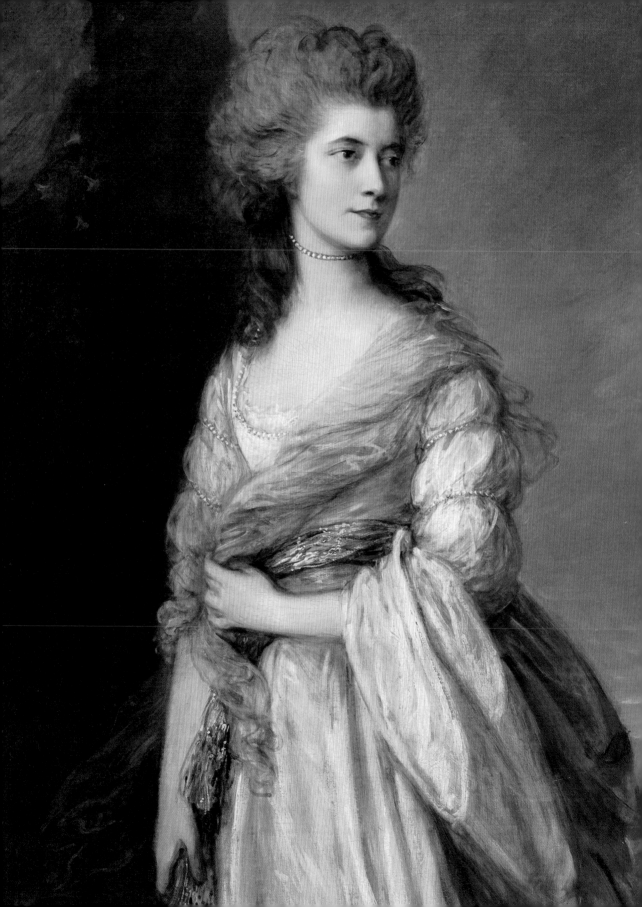

BRYAN FERRY

Thomas Gainsborough, *Mrs. Peter William Baker*, 1781; *The Hon. Frances Duncombe*, ca. 1777; *Grace Dalrymple Elliott*, ca. 1782; and *The Mall in St. James's Park*, ca. 1783

I spent my childhood in the town of Washington, in the northeast of England, on a street called Gainsborough Avenue; and for as long as I can remember, I have felt a strong connection to that particular artist. My neighborhood was neither deluxe nor delightful—I can't imagine anywhere more different from Henry Clay Frick's dream home and its splendid location on the Upper East Side.

Nowadays, whenever I come to New York, I head across Central Park to the Frick and the guaranteed calm of the Dining Room with its Gainsborough portraits—a welcome contrast to the frantic city outside, dominated as it is by grids and straight lines. I love the way these superb eighteenth-century paintings hang in a decorated setting, with carpets, curtains, furniture, and flowers echoing the refinement of that period.

As to the works themselves, Frick chose wisely. The three female portraits are famously beautiful and truly Warholian in their subtle flattery. What ties them together is Gainsborough's marvelous *Mall in St James's Park*, which demonstrates his love of landscape and of London's finest park.

Together these pictures display all the qualities for which Gainsborough was famous: delicacy, poise, restraint, and a certain kind of cool—which, speaking as a musician who trained as a painter, I find in a Miles Davis trumpet solo or the laid-back phrasing of the great Lester Young.

I always find great comfort and inspiration in this calm place.

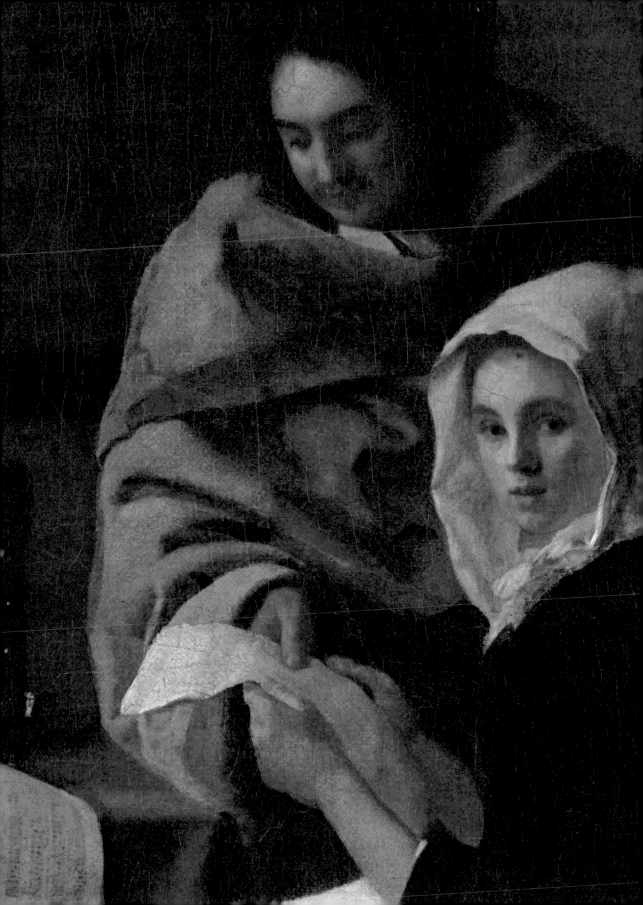

MICHAEL FRANK

Johannes Vermeer, *Girl Interrupted at Her Music*, ca. 1658–59

What could be cheekier, after Proust, than daring to drop into a novel a scene built around a visit to a painting by Vermeer? In *The Prisoner,* the fifth volume of *In Search of Lost Time,* Bergotte, a writer and one of Proust's stand-ins in his masterwork, defies his physician's orders to rest when he learns that Vermeer's *View of Delft* is on rare exhibition in Paris. An art critic has mentioned, in particular, a patch of yellow wall, which Bergotte for the life of him cannot remember, despite the painting being one he "adored and imagined he knew by heart." Bergotte lunches on a few potatoes, then takes himself to the exhibition. As he studies the painting, he grows dizzy, and his gaze fixes on the yellow patch. "That's how I ought to have written," he thinks. "My last books are too dry, I ought to have gone over them with a few layers of color, made my language precious in itself, like this little patch of yellow wall." Then he sinks down onto a circular settee, rolls over onto the floor, and dies.

This moment is not Proust's only connection to Vermeer, in the novel or in the author's life. Swann, of course, struggles (and fails) to finish his study of the painter. In May of 1921, a year and a half before he himself died, Proust left his house for the last time—and was photographed for the last time—when he went to see an exhibition of Dutch paintings at the Jeu de Paume, worrying all the while that he, like Bergotte, might collapse at the museum. Life echoing art, or art echoing life, or both.

In my own far more modest way, I send Costanza Ansaldo, the central female figure in my novel *What Is Missing,* off to see the Vermeers at the Frick one afternoon in the company of her fierce mother, Maria Rosaria. Mother and daughter are several days into a détente of a visit whose peace is abruptly broken when Maria Rosaria, after examining *Girl Interrupted at Her Music,* turns to her daughter and says, "Do you honestly think this young girl will continue to study her music once that fellow comes into her life?"

Costanza reads her mother's response to the painting as a clumsily encoded criticism of her: for translating, rather than writing, fiction; for diving into a new relationship with a man; for having moved so far away from Genoa, where she grew up and where her mother still lives. It's quite a burden to place on a canvas whose power—I have always felt—rests in its fundamental inscrutability. Even Costanza, to my mind, goes off on a personal (if more reasonable) tangent when she thinks to herself that the true subject of the painting is time: time, stopped in paint, expressed through light, caught on a sleeve, a sheet of paper, a face.

Is either woman right, are they both wrong? Does anyone know for sure what this Vermeer, like so many of its siblings, is definitively *about?* In *Girl Interrupted at Her Music,* it's not clear whether the man is her teacher or her suitor; or what the painting within the painting (of Eros, which hangs dimly in the background and is partly obscured by the male figure) is intended to imply; or whether some metaphorical interpretation is to be made of the birdcage hanging next to the window; or how much ease or intimacy between these two figures the glass of wine on the table suggests; or why, above all, this enigmatic girl is looking at us directly and with a gaze that is itself ambiguous and every bit as challenging and noncommittal as the painting it peers out of.

"We feel in one world," Proust writes in *The Guermantes Way.* "We think, we give names to things in another; between the two we can establish a certain correspondence, but not bridge the gap." In Vermeer, this gap, it seems to me, is the source of the peculiar gravity that keeps drawing us back to his pictures—and back again.

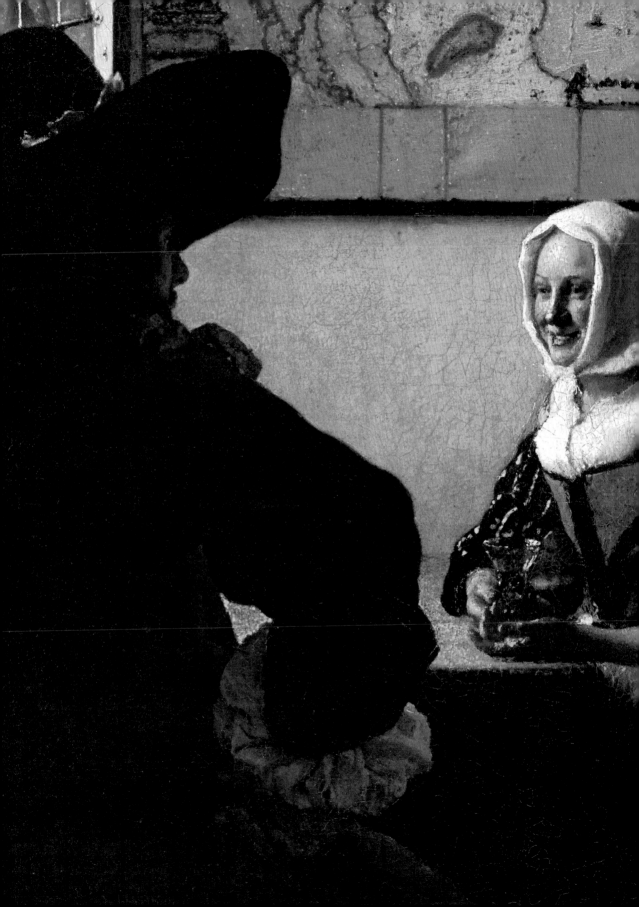

MOEKO FUJII

Johannes Vermeer, *Officer and Laughing Girl*, ca. 1657

When we were young, ten or so, my mother would take my sister and me to the Frick. She would tell us to run off and choose a favorite painting, have us guess each other's, then tell each other why.

It had been a year since we'd moved from Japan. We knew to be careful and quiet. We watched each other out of the corners of our eyes, dallying in front of the obvious ones. My sister's favorite: the impish lady with the cup-sized shoes, stretched out next to the samurai doll. Mine: the lady in white draped in Whistler's woodblock flowers. The heavy audio guide swung like giant amulets around our necks as we ran from painting to painting, telling us that they were inspired by Japanese art. That made us feel special. We felt that we should love all paintings made by westerners who'd loved Japanese art.

After a while, we would find our mother standing in front of a Vermeer. She called it "Lady Listening." It was her favorite. No, there weren't any Japanese things in it. Still, look girls, at that man so strangely in shadow. That elbow! You know he likes to talk. And there, the curl of his fingers. The woman, well, she wasn't as transparent. Why was she smiling? My sister and I stared. I didn't know what to make of the woman's left palm. Was the hand stretching toward him, was he so important? My mother's finger hovered over the diamond glass in the window, the creams, the yellow—so bright on the lady's lips—and the shifting blues on the map. We don't always look at women listening, my mother said. And there were worlds she had yet to see.

My mother told us that he was a traveler. She thought he was speaking in a foreign language to the woman, one she was not comfortable with—yet. We asked her how she could tell. That smile, she said. She's smiling because she's trying hard to make him feel heard, to show him that she understands. My mother stared at the painting, flanked by her girls dressed in matching blue frocks. Renoir frocks, she said in English under her breath, when she dressed us to go to the museum. We—sisters who could no longer remember a time we relied on a single language—would repeat the words back at her, rolling the R's with a cruel ease, and she would listen and smile. It was different from the one on her face as she stood in front of her lady, transported, her own map unfurling, until we found her. We didn't understand the difficulty, or the dose of make-believe, of traversing tongues.

"Alternative title: *Mansplaining*," a friend said recently, after glancing at the man's confident red back, his cocked elbow. Later, I turned back to the painting. The shadow still fell on the man's shoulder, and the light, on a quiet smile.

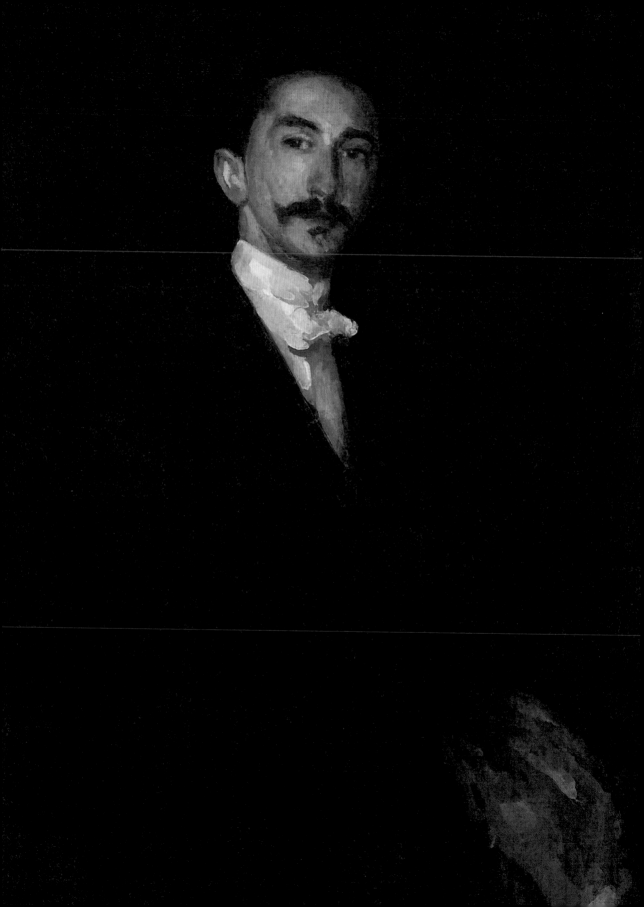

ADAM GOPNIK

James McNeill Whistler, *Arrangement in Black and Gold: Comte Robert de Montesquiou-Fezensac*, 1891–92

Perfect elegance, with something rotten in it somewhere. This was my initial response to this picture, seen first some forty years ago. Having just started reading Proust, it put me in mind of the first volume of Proust and therefore of Proust's depiction of the elegant, ambivalent heterosexual Swann rather than of the later books, which include, under the name of Baron de Charlus, exactly this guy: the Baron de Montesquiou.

How is he elegant? Let us count the ways. The slender attenuation of his body, reduced to a two-dimensional shadow—we feel we might be able to roll him up, like a window blind—the quizzical, suspicious turn of the head, like that of a character from Lewis Carroll: "Who are *you*?" said the Caterpillar. How rotten? Well, not rotten so much as knowing, the kind who would stab you in the back with malicious gossip as soon as look at you.

Whistler—deliberately foxy, like all great artists, in putting critics and professional big mouths squarely off the right scent—made much of the purely formal properties of his pictures, trying to show dimwitted philistines that the crucial parts of a picture are all the parts that can't be inventoried in an account of its subject. And so, he loved to give his pictures abstract names, *Arrangement in Black and Gold* and so on.

Yet the paradox is that Whistler's gift for the analysis of character and the suggestion of mood was much greater than his merely formal or "harmonic" gifts. Sargent is incomparably more vivid and virtuosic in his portrait making, and even a lesser artist like Paul César Helleu can be as dazzling. Whistler's gift was for the X-ray of emotion: he conveys not merely the self-image of his sitter but some of the self-doubt beneath it.

If one wants to see the difference between talent and genius, someone said, watch Gene Kelly dance and then Fred Astaire. To see the same difference in painting, look first at Boldini's portrait of Montesquiou and then again at Whistler's. Boldini buys in. He takes the aristocratic self-creation at face value in every sense: the rococo mustache, the arrogant turn of the head, the indulgent manner. Whistler sees past the impersonation. Anxiety, doubt, self-reflection, sexual ambiguity: we feel it all. The cultivated mustache with its zigzag hem is softened and reduced—one has to look hard to see its kink. There is, in the turn of the wrist, just a touch of the "effeminate" quality in the sitter that Proust would see too and make so much of as the source of Montesquiou's self-doubt. And the cloak he holds—is it his own or a woman's?

This is the aesthetic turn at its most anxious, the human body made into a letter opener and life into a series of envelopes to be pierced, a set of evenings to be impaled. The literary virtues of the portrait bring us back to it again and again, and the older we get, the more we see the character in action; at eighteen, as a dream of sophistication our sneakers will not allow us to inhabit; then, as part of a lost world of specifically French glamour; and eventually, as an image of a social world known too well, where appearances deceive and the man with a paper knife's body can turn around and cut your throat. One might almost create a paradox in the artist's own pet manner and say that, while Proust drew the character, Whistler wrote the book.

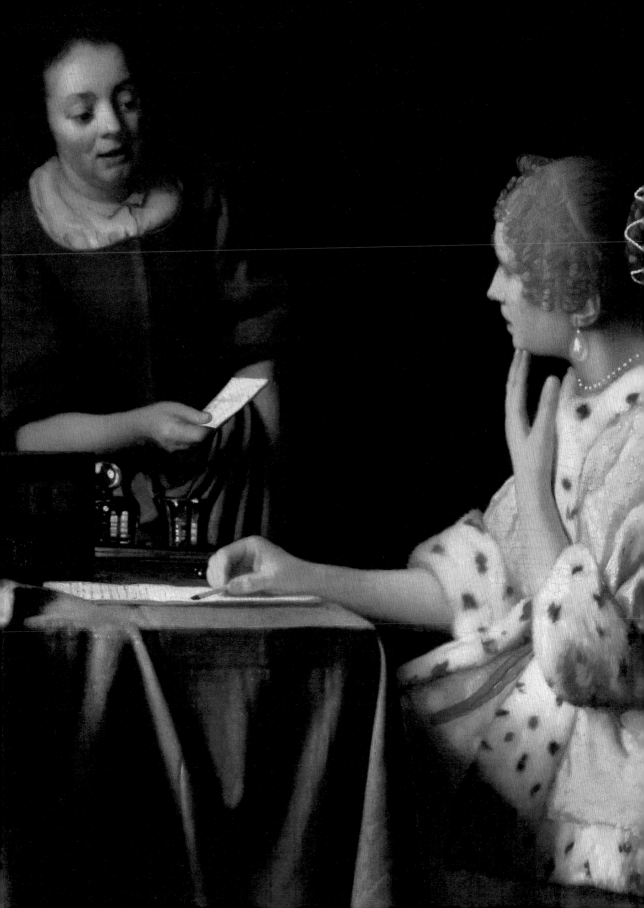

VIVIAN GORNICK

Johannes Vermeer, *Mistress and Maid*, 1666–67

The commanding element in this painting is the dazzling pool of light gathered in the lower right-hand corner of a canvas occupied by two figures settled in a background of solid darkness—as though the painter wants nothing to distract us from the small drama to which these two are calling our attention.

The figures are a pair of women, one a plainly dressed servant, the other her richly clad employer. The maid wears a kind of shapeless black that makes her seem at one with the darkness behind her. The mistress wears a strongly yellow, fur-trimmed dressing gown in which the painting's celebrated light is gathered. This lady is writing at a small table covered in a fine blue cloth when the maid appears before her, proffering a letter she holds in her hand. With all her privilege, the mistress, nonetheless, upon seeing the letter, has involuntarily raised her fingertips to her chin in an attitude of unmistakable anxiety; the glimpse we have of her face, mainly turned away from us, seems to echo the worried insecurity I see in the upraised hand.

Taking all this in in one swift sighting, I immediately think, She's having an affair, and she's certain that the letter is from someone who has seen her with her lover and is threatening to tell her husband. Something in her posture, I really don't know what, makes me wonder, Is this affair an errant fling or a compelling passion, a flight from boredom or a true awakening? Does her anxiety include regret or, no matter the strain, has it all been worth it? The maid, whose face is ever so slightly collusive, seems to be a willing ally, in on the situation and ready to comfort. Nonetheless, the mistress is clearly alone in this moment of threatening exposure.

I turn away from the painting and walk out of the museum into a brilliantly sunny afternoon on New York's pristine Upper East Side, feeling deliciously melancholy.

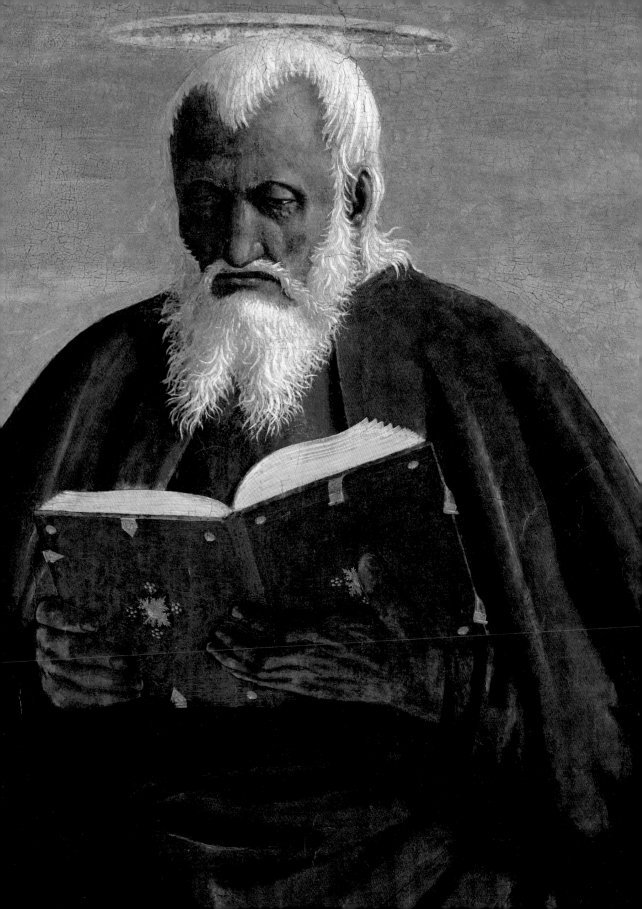

AGNES GUND

Piero della Francesca, *St. John the Evangelist*, ca. 1454–69

The Frick has been instrumental in forming my taste. It is one of the museums that taught me that one could express one's personality through collecting, and it inspired me. My eldest daughter once laughed when I told her that if I were ever locked away or trapped somewhere, I would maintain my sanity by picturing the Frick in my mind. I have memorized the layout of the museum and the exquisite details of favorites such as Piero's *St. John the Evangelist*.

The wonderful way the Piero is situated in the Enamels Room draws your eye to it so that it becomes a focal point between the archways, visible from the Oval Room and the West Gallery. There is something so ethereal about the figure, as if it were levitating or otherwise soaring. This quality is enhanced by the painting being hung above eye level. The figure's feet seem entirely too small for the body and subtly blend into the bottom of the painting, almost disappearing. Similarly, the left foot is obscured by what I think is the top of the throne of the Virgin in a missing central panel. I recall reading something years ago that mentioned that an X-ray of this work revealed that Piero painted the whole foot even though he knew it would later be obscured. It is amazing to me how meticulous an artist he was and the degree to which he mapped out his figures.

One reason I am drawn to this painting is that it is a study in contrasts. For example, the pallid tones of the figure's exposed hands and feet are in stark contrast to the rich, ornate reds of his majestic robe. I love the contrast of the earthy, bare feet with the highly decorated, elaborate, and saturated hue of his garment. I also adore Piero's treatment of the glowing golden nimbus and how this contrasts with St. John's somber and serious face and reverent expression as he is utterly absorbed in his prayer book. I could not imagine the Frick, this magical sanctuary, without this masterful Piero as a constant presence.

CAROLINA HERRERA

Francisco de Goya y Lucientes, *Don Pedro, Duque de Osuna*, ca. 1790s

The Chilean collector and *maecenas* of Versailles Arturo López Willshaw once said, when visiting the palace, "When I come here, I always feel somehow at home." That's how I feel about the Frick. I would love to move in. And, as one does in one's house, I would like to move the furniture around, hang the paintings in different places, and put some of the objects away, to change them from time to time.

There are so many things that I love in the Frick, but there is always something that you love more than anything else, a painting that for some reason touches you. My favorite is Goya's portrait of the duke of Osuna. You may ask why. The truth is that I am an old friend of Goya's portrait of the young duchess of Osuna. This beautiful painting is hanging in the house of friends who live in Madrid, and whenever I go to visit them, the duchess is the first person I say hello to. And I give her a tender message from her young husband at the Frick in New York.

The Frick is always full of surprises. In one of my visits, I came unexpectedly into the East Gallery and was struck by the magic force of the Zurbarán exhibition *Jacob and His Twelve Sons*. Zurbarán has been a favorite painter of mine since I was a girl and saw his work for the first time in Seville. But I had never seen these incredible people before! This is what makes the Frick unique. The genius, beauty, and mystery behind its doors may change your life.

ALEXANDRA HOROWITZ

Thomas Gainsborough, *The Mall in St. James's Park*, ca. 1783

The Mall in St. James's Park is not about the dogs. With the light focusing our attention on three clusters of women strollers—elegantly dressed and subtly checking each other out—Gainsborough captures a moment of a particular eighteenth-century London social scene.

But I am an animal cognition researcher, with my focus on domestic dogs, so I'm trained to seek out the quadruped in the scene. And so I spy, at the feet of each band of walkers, a tiny dog. One is a Pomeranian—the eighteenth-century version, with longer legs and nose, less of a stuffed toy than a vulpine variant of "dog." Another, a terrier, head tilted questioningly. And a setter mix, with lopped tail and shiny collar. Just as the human cliques eye each other, each dog is keenly aware of the others. The two in the foreground bound in half-play bows, inviting each other to a game. Yet both remain within the swirl of their owners' long skirts. The terrier shyly stays in her lady's shadow.

In films, at times, dogs are plot devices more than they are actors. They are used to lend an effect of reality, as Roland Barthes describes it, to the story. A dog barks; the plot pivots. Another dog's behavior serves to walk actors into a new scene or interrupt a conversation with a whimper or growl. Dogs are punctuation, heightening the viewer's sense of what is happening. Or dogs are window-dressing, part of the landscape. What dogs are not is actual dogs.

In this painting, similarly, Gainsborough's dogs add authenticity to the scene: dogs were the perfect appurtenance to a kind of upper-class lifestyle. Even before the race to purebreeding that arrived with Victorian England, there were certain dogs who were meant to be companions for refined ladies. The first complete list of "Englishe dogges," by Johannus Caius, includes dogs whose function was expressly "to satisfie the delicatenesse of daintie dames." These dogs, called Spaniel-gentle, or Comforter dogs, were "instrumentes of folly for [ladies] to play and dally withall, to tryfle away the treasure of time."

But unlike in film, Gainsborough's dogs are not symbols; they are dogs. They are acting out in an entirely undignified—but fully doggy—way. While the women hold their shawls tight, glancing at one another demurely, the dogs bound and wag. Each has its own personality, expressing itself with body and gaze. Moreover, they are exquisitely drawn. Their anatomy and comportment are spot-on, the work of a diligent observer of dogs. We all know what a dog—the Platonic "dog"—looks like. These dogs are not that dog. They are individuals. Indeed, they are more differentiated from each other than the women who are the ostensible focus of the scene.

I've spent hours staring at this image. The more I look, the closer I get, the more the women blur together, and the more the dogs stand apart. And, finally, I also see that there are other quadrupeds in the image: a small herd of horned bovines, moving through stage right. Those are some strange dogs.

ABBI JACOBSON

Meissen Porcelain Manufactory, *Two Birds of Paradise*, ca. 1733

I have been thinking about love a lot lately—what it is, what it's not, and more often, what it *could* be. *Two Birds of Paradise* looks a lot like what I want love to be—of the romantic kind, if I ever should find it again. The untethered joy of freedom, to be perched alongside another who is just as free, just as wild. Crude but deeply glazed wings flapping as we squawk back and forth, our intricately drawn legs holding up our weight. A smile sent as an understanding, a mutual agreement of belonging to each other, and to life itself. Paradise only exists with two.

BILL T. JONES

Jean-Siméon Chardin, *Still Life with Plums*, ca. 1730

Meeting Chardin's *Still Life with Plums* As a performer and maker of theater and dance, I've often been con- fronted with audience members clamoring to know, "What does this performance *mean*? What is its message?" I have found it useful to encourage these viewers to watch themselves watching. This advice rang loudly when I accepted the invitation from the Frick to write about a work in the collection that speaks to me. Like many in our identity-driven era, I am burdened (or gifted, depending on one's point of view) by the need to see myself and my experience in all cultural products past and present. The personalities, deities, places, and events represented in the various works of art at the Frick leave me exhilarated but also exhausted by this need to "see myself."

It is Chardin's *Still Life with Plums* that I am most drawn to, and this has something to do with the absence of human figures. This small-scale, expertly rendered depiction of a green bottle, a glass of water, a couple of vegetables, and a basket of plums is a peculiar mirror through which to "watch oneself watching." Call it habit, but I look at the world inside the frame as a kind of stage. In my art form, the basic elements are space, time, and gesture. These elements are present, though altered, in Chardin's mysterious, concise composition.

Space in this compressed two-dimensional world is a deft illusion. The relationship among the various objects, like players on a stage, would have us believe we're in the presence of a unified group, but in truth each object is bound and isolated in its "thing-ness," participating in a community by the artist's crafting of pigment, shape, and, yes, light. Time here, represented by light itself, is what gives this work an eerie otherness, as if suspended in a dimension, a place, outside of time. I often call this "the theater of the mind." Most artists toil there and find it near impossible to say what happens when the viewer enters this realm.

Gesture in a world where all movement is arrested, called *nature morte* (dead life) by the French. The connoisseurs would lean closer to examine brushstrokes, but for others, gesture is the dance of an invisible hand, mind, and heart, which needs to create such an illusion. Even though *Still Life with Plums* has no distracting human figures, its very existence—as suggested above—is proof of human agency. Like many other painters of the time, Chardin was indebted to the Dutch, in particular to Vermeer. The art historian Jean Leymarie attributed the rise of Dutch still life in the seventeenth century to the desire felt by men of the time to make themselves into what Descartes called "masters and possessors of nature," a desire inferred by "the outlook of a realistic-minded middle class society founded on the free exchange of goods, a society accustomed to assessing things in the light of their practical utility and market value."

And so, the "self," my self is torn here. Chardin's lovely, curious mirage was painted at a time when I, as a black person, could have been the property of the owner of this magical arrangement of things. So, do I experience a kind of empathy for the objects in this painting having a history in which I too have been reduced to objecthood— "thing-ness"—with "a practical utility and market value"? That being said, history, economics, and morality in the eyes of the viewer become an impediment to seeing this picture. This is the case with all art that survives its era of creation. As Diderot said in his eulogy of Chardin, "He used to say that the hand and the palette are needed in order to paint, but that painting is not made with the hand nor the palette." Might I paraphrase as a response to my engagement with *Still Life with Plums*: The eyes are used to recognize the visual world, but we need more than eyes to "see" this painting!

Francisco de Goya y Lucientes, *Portrait of a Lady (María Martínez de Puga?)*, 1824

Why am I so wild about her?
I am pretty sure it is the scalloped hair.
The scalloped hair and the eyebrows.
And the color of the background.
And the black of her dress against the taupe background.
My mother said taupe was a great color for shoes
because it goes with everything.
So the taupe is good.
And the strangely big white glove.
And her neutral gaze.
Pensive? Uncomfortable? Indifferent?
It is near the end of his life, after the black paintings,
and he can do this with his eyes closed.
Maybe he said, I can do this with fewer strokes.
With less. Hello impressionism.

Lately, every time I leave the Frick, I go to
Ladurée and have a pot of tea with tea sandwiches.
They are wrapped in wax paper and labeled.
Comté cheese.
Tuna and cucumber.
Ham and pickles.
Salmon and cream cheese.

I have taken to saving the wrappers.
They will always be together.
The painting. The Frick. The tea sandwiches.
Which is pretty much all I need.

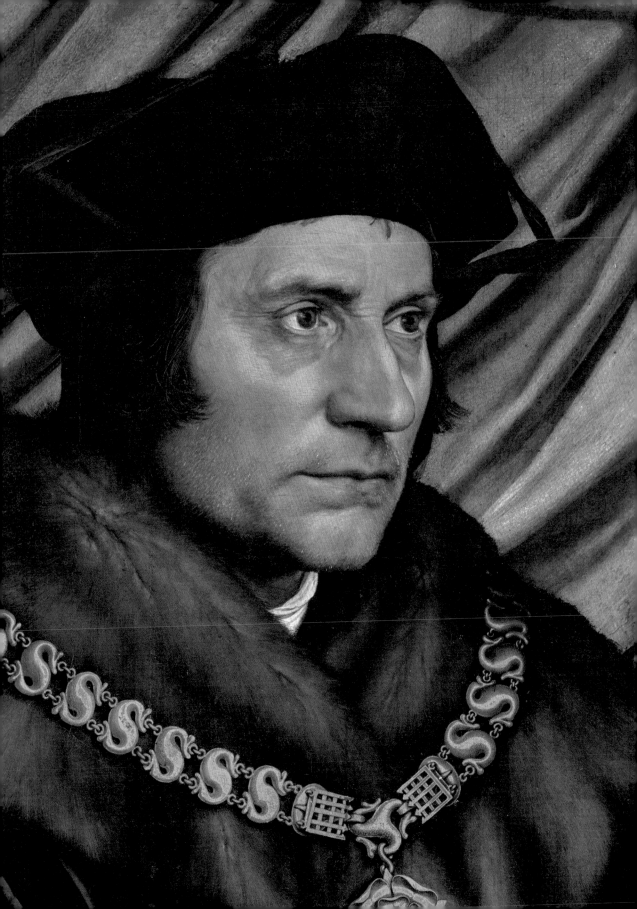

NINA KATCHADOURIAN

Hans Holbein the Younger, *Sir Thomas More*, 1527

Every time I visit the Frick, I go to the Living Hall to look at Holbein's portrait of Sir Thomas More. I love it as a painting, but I also see it as the first spark in a series of chain reactions that happen among objects in that room.

There is an enormous fireplace in the center of the main wall. To the left, there's More, eyes looking to his left. To the right of the fireplace, there's another Holbein portrait: Thomas Cromwell, More's arch political rival, eyes looking to his right. The huge stone fireplace tries to be a physical and energetic impediment, but it cannot interrupt the glaring between the two men, which is like a constant low frequency in the room that can't be masked. Above the fireplace is El Greco's St. Jerome, looking like a parent who is trying to keep rival siblings from killing each other.

In line with this symmetry, below each of the Holbein portraits is a small Giovanni Francesco Susini sculpture in dark bronze. Under Sir Thomas More, a lion attacks a horse whose long, Loch Ness Monster–like neck arches back in dramatic agony as its front legs hover in space, like a horse on a carousel. Under Thomas Cromwell, a leopard attacks a bull. The leopard has a furrowed brow and a head whose fur pattern makes me think of men with receding hairlines. The leopard digs its claws, with noticeable gusto, into the back of the bull, who staggers and buckles at the knee as he submits, overwhelmed.

Given their placement, the sculptures feel like an overt embodiment of the conflict between these mortal enemies, More and Cromwell. The contained tension that is set up between the two portraits separated by a gap finds its explosive release in the sculptures, one animal tearing apart the other in a violent tangle of bronze. I feel sure that someone wanted me to experience this and very deliberately placed these objects in these relationships for that purpose. The whole wall snaps with energy; the sculptures send me back to the paintings, and to the history of these two Thomases. It is a staging of masterpieces that is itself a masterpiece of staging.

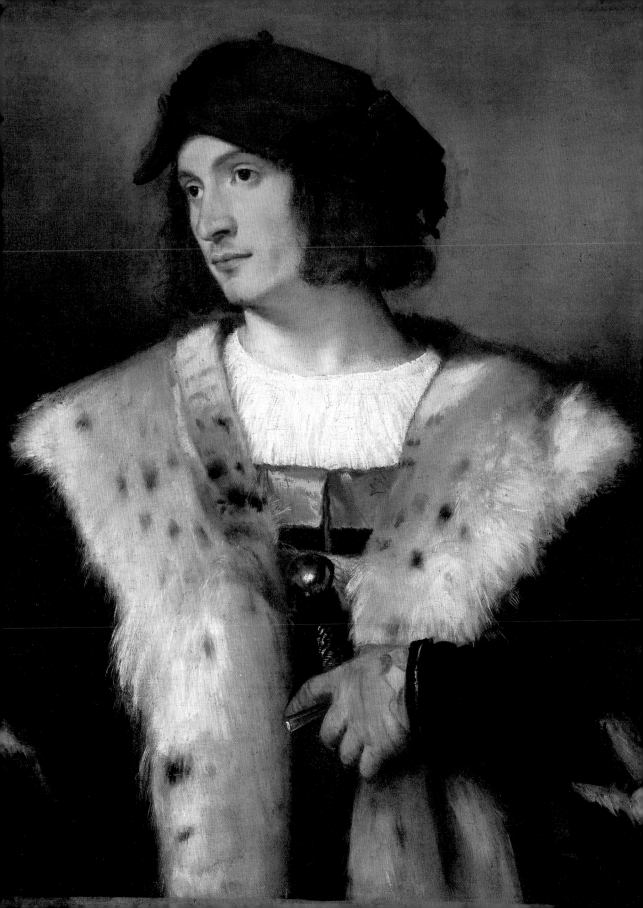

SUSANNA KAYSEN

Titian (Tiziano Vecellio), *Portrait of a Man in a Red Cap*, ca. 1510
Agnolo Bronzino (Agnolo di Cosimo), *Lodovico Capponi*, ca. 1550–55

There is The Frick Collection, and then there is a Frick Collection of the mind, where the only paintings are those that have left an imprint on me. The ones I am thinking of today are two portraits, which I've hung side by side in a long salon. They are not, in fact, in the same room, let alone neighbors on the wall.

One is by Titian: the sad-faced man in the red cap. He has an ermine-collared robe, and he is looking to the right. But from my point of view, he looks to the left, into the past. Something there has made him mournful. His beautiful hat has two flaps folded up in front and a faint tassel in back.

In the museum of my mind, this painting is larger than life. But it isn't. Its dimensions are quite modest.

The second painting is the Bronzino portrait of Lodovico Capponi, an expressionless young person. In my museum, he is wearing an extraordinary puffy doublet slashed green and white. But this is wrong, again. He's wearing a somber black garment, and the only notable thing about his getup is his codpiece, which reads as a silver erection. What is vivid and alive in the painting is the green backcloth, whose folds and curves and swags express all the emotion absent from Capponi's face. No surprise that my private version transforms the background into the subject.

It is the Bronzino that is larger than life—the egotism of youth.

I know these people: the sulky teenager brooding on his lusts, the older, no wiser man and his regrets. I have been these people. That's why it's good to visit them, at their actual house on Fifth Avenue or in the hodge-podge collection in my head.

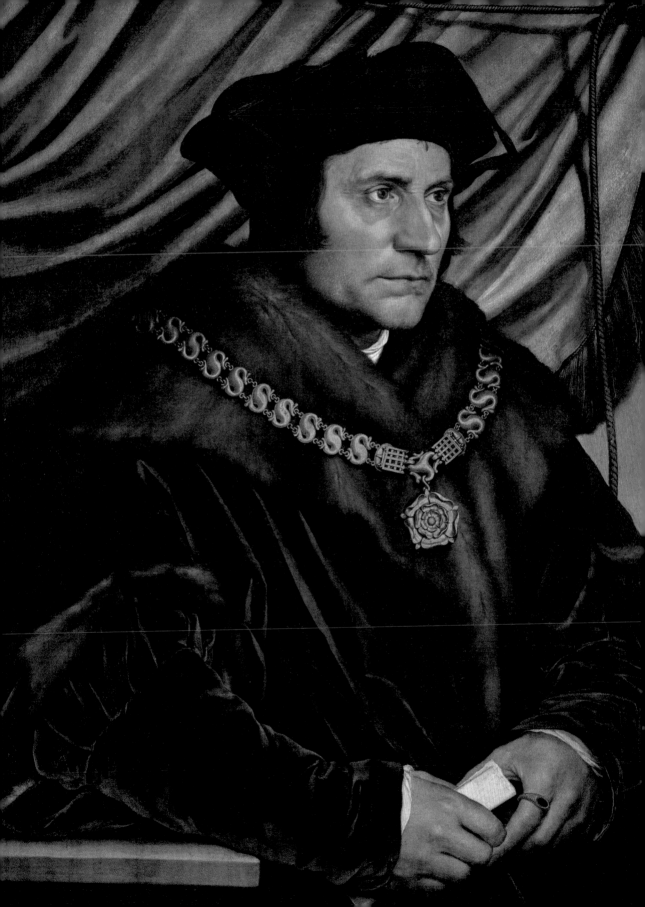

JONATHAN LETHEM

Hans Holbein the Younger, *Sir Thomas More*, 1527

I grew up going to the American Museum of Natural History every year—it was a pro forma class trip for a public school kid, even from Brooklyn. My father was a painter, so if we hit the uptown museums, instead of SoHo galleries, it was MoMA, the Whitney, and the Guggenheim. In my high school years, I remember the epochal Picasso show at MoMA in 1980, the Whitney's Alexander Calder in 1981. The Met I went to with my grandmother, once or twice, and knew from *From the Mixed-Up Files of Mrs. Basil E. Frankweiler*. The Frick was a secret, left for me to discover.

I did it with my best friend the last year of high school, Peter Cohen. We were both painting and carving marble at the High School of Music and Art, on 135th Street in Harlem, had both already gotten into college, and weren't paying attention to anything other than making paintings and carvings and getting stoned after school and wandering in Central Park. Peter knew about the Frick. We thought the name was funny. Though we paid admission, it felt as though we were sneaking in. Peter already had his favorites there, and he led me to them. It felt like a kind of rebellion against modernism, to be so interested in virtuosity—in photorealism before photography, in the Vermeers, the Dürer drawings, above all, in the Holbeins. Cromwell and More.

Peter and I did this three or four times, enough that it seemed legendary, a rite: we blew joints on boulders in the sweaty, busy park, then threaded among the rollerskaters and blaring boomboxes, moving west to east (we'd have gotten off the C train at 81st Street, probably) to Fifth Avenue. Then, giggling, entered the hushed, cool stone temple. We weren't, as I say, sneaking in, let alone spending the night there after hours in the manner of *From the Mixed-Up Files*, yet we still felt like spies, like invaders—termites in the elephant temple, worms in the bud. We alone understood that the art was psychedelicized, talking to us through the centuries. These painters were freaks of devotion, providing eyeball kicks for acolytes like us.

Cromwell was a pinched nerd. He reminded us of one of our uptight painting teachers. We dug his hand, though. We stared a lot at that hand. More was our favorite, More was sublime. I was into science fiction and knew he'd written *Utopia*. Whatever it was. And More had that outlandish beard stubble, the weird "S-S-S" necklace, and, above all, the velvet sleeve. The sleeve was ecstasy, the sleeve should be illegal, the sleeve was Utopia. We fell into the sleeve. If you look close, we're still in there, falling.

KATE D. LEVIN

Lazzaro Bastiani, *Adoration of the Magi*, 1470s

Maybe because I spent twelve years wearing a school uniform, I've always been fascinated by artists who wrestle deeper meaning out of conventional subject matter. Bastiani's *Adoration of the Magi* walks that ultimate tightrope, both respecting and exploding all the tropes of nativity scene painting.

I get the difficulties of the subject, starting with the centerpiece of these images. The Savior, as a newborn, is in the most visually generic state of humanity. Mary can't distract the viewer from the Holy Infant. And what to do with Joseph? In religious terms, he's the vessel of humility and faith; in secular terms, a painful figure of male irrelevance. In versions that include the Magi, how to keep eyes on the Holy Family in the midst of exotic luxury?

I always want visceral awe, but most of these compositions don't convey more than generalized reverence.

And then there's Bastiani. His version is so moving because it forges the sacred out of the utterly human. Here is both spiritual *and* literal baby worship: one of the three kings on his hands and knees, caressing the feet of the Christ Child—who is smiling in delight up at his mother. Joseph's ambivalence is clear—he hovers, embracing an architectural element, a pillar of the story but not central to it. And the older woman in the doorway behind Mary! Finally: acknowledgment that a post-partum mother and newborn need experienced care, not just an ox and ass for company.

Throughout, Bastiani celebrates his own technical virtuosity. The central king's robe is a highly detailed textile, with that same pattern resized and reoriented on a servant standing in the background. Forced perspective pulls the eye up across a river to a minute tree—that is legibly asymmetrical. In the sky, several rafts of boldly colored angels hover over the proceedings. The work radiates both faith and brashness.

And there is the prone king's crown, on the ground beside him as he reaches for the Savior. What anyone would do around a baby; what a perfect symbol of subordinating man's authority to Christ's majesty.

This small, brightly colored fugue of iconography made earthly pays attention to this story in ways I've never seen before. Bastiani's radical imagining—his sense of yearning, of humor, of tenderness—really does transpose the human and the divine.

DAVID MASELLO

Agnolo Bronzino (Agnolo di Cosimo), *Lodovico Capponi*, ca. 1550–55

My Friend Lodovico Years ago, upon breaking up with someone after an embarrassing public argument in Central Park, I went to see Lodovico Capponi. I needed his approval and reassurance. He was also one of the first people I visited in the days after September 11. Whenever friends are in from out of town, I take them to meet him, and if I find myself in his neighborhood, I drop by to simply stare at him with actual love. I have yet to tire, after more than thirty-five years of visits, of seeing the four-foot-high oil portrait and taking in his wavy, red-brown hair, flawless complexion, and wandering left eye.

I have known Lodovico for as long as I've lived in New York, having come to the city right after graduation from the University of Michigan and, before that, my home in Evanston, Illinois. After all these years, I keep asking myself the same question: Why do I continue to visit this mute, overdressed, imperious young man? Many people to whom I introduce him find him austere, even humorless.

When I was close to Lodovico's age, about twenty-two, some people said I resembled him; my right eye wanders lazily in the way his left does; my nose appears equally ample and Italian. I suppose it's natural we are attracted to those who remind us of ourselves. Lodovico was a constant in my early years in New York. I always knew where to find him, and being a painting, he would never change or age. At a time when I still had few friends and a fragile self-confidence as a young man in a new city working for a book publisher, I admired Lodovico's regal bearing, his unblinking confidence, and his solid ownership of a defined station in life. While he married the one he loved, mine remains unattainable.

Lodovico is my Dorian Gray. Because he'll never age or fade, neither will my memories of life in New York in my early twenties, when Lodovico was one of the first figures I met and came to know. If he were able to see, he would have discerned a portrait of me standing before him—alone, with various partners as they came into and out of my life and with strangers who lean over to share their thoughts about the painting.

I know that if he came to life, we would eagerly teach each other the ways of our time. I wouldn't know how to negotiate the intrigues of Medici court life, and he wouldn't understand airplanes or gluten-free pasta. But I'm sure our friendship would be an easy one. We would be, as is said in Italian, simpatico.

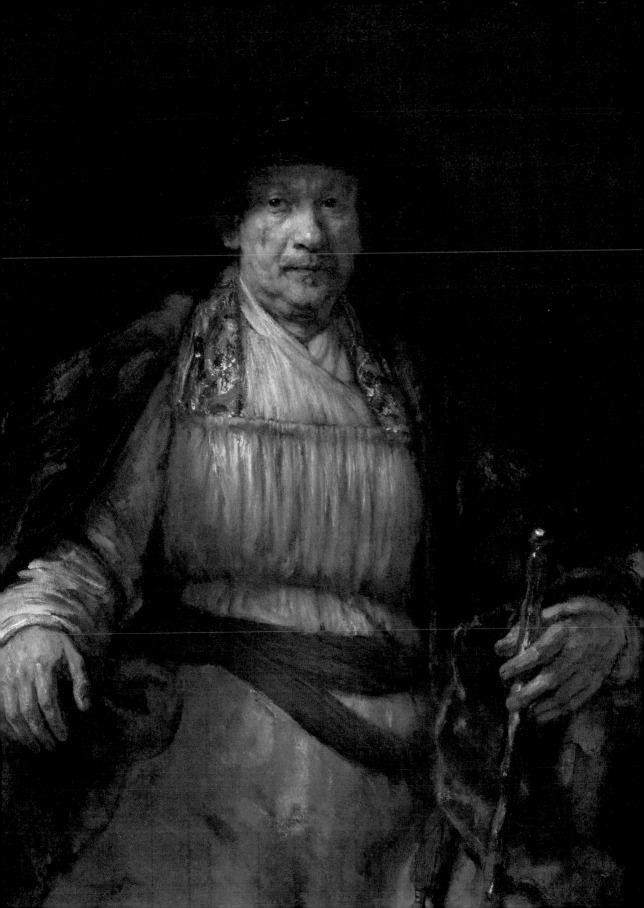

JULIE MEHRETU

Rembrandt Harmensz. van Rijn, *Self-Portrait*, 1658

My first memory of a charged, transformative encounter with a work of art was from a reproduction in my mother's Rembrandt book.

I remember her taking me through the pages at the dining table, describing her feeling that Rembrandt painted as if painting light itself. Piece after piece, pointing out the light and the shadows—I remember seeing her face change as she searched the eyes in each work.

The Sacrifice of Isaac captured me one Saturday morning, utterly illuminated by the sharp light of winter sun. It felt as if time had paused.

There he was, Isaac, his vulnerable chest and neck open and exposed, as Abraham's deft hand forces back his son's head. Of course, I must have been moved by that, the story itself, the horror that a father would sacrifice his son.

But what I remember shining through, what I kept coming back to, was Isaac's tender skin, painted to feel the breath in him, the light from inside his naked innocence and vital core.

The paint strokes taut and fragile, his skin material paint,
I can see it in my mind's eye, now.
Caught between breath and fresh steaming blood.
How does paint feel; you can see it there, on the surface, *how does he do that*,
make material flecks of paint inhale, quiver?

Rembrandt, my first love as a young artist,
(my first teacher)
still a major touchstone.

Forty-one years later in front of Rembrandt's self-portrait,
I am left astonished and marveling
Mesmerized by his skin,
Every single time I come to visit, to study (this painting).

The master,
grand, large, imperial,
he throws down the gauntlet with this piece,
to all painters past and those to come
—*touch this, just try*
his stance, the heft of his arms, his royal robes,
an authority,
painter, maker

Face, ravaged, marked,
eyes shining but settled deep,
mournful, erudite, commanding,
he sits there, in his power but also

laid bare by loose flecks of oil and paint,
amber, umbers, vermillion, cadmium,
pyrrole on his cheek,
his suffering
felt, time and sorrow carved by the palette knife,
worn,
His hands, mighty
holding the arm of his chair and brush or scepter,
pure traces of the brush
Of loose paint,
the strokes of practice, time, age, loss.
Made by those very hands,
Pure touch
disintegrating, transmuting right there,
with you as witness,
while he stares down
not imperious, or punitive,
but forceful and pitiful,
scarred and bare.

The ferocious gold fire of his core, his tunic,
glowing and splendid,
illuminating the entire painting,
illuminating you too dear viewer—his witness,
permanence
graced and desperate at once.

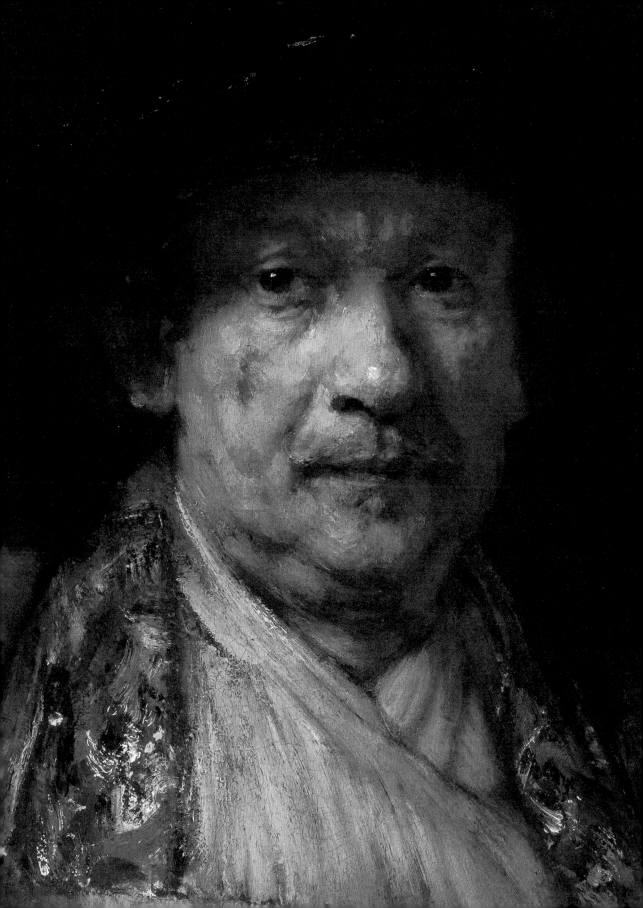

DANIEL MENDELSOHN

Agnolo Bronzino (Agnolo di Cosimo), *Lodovico Capponi*, ca. 1550–55

People don't generally talk about the emotions in Bronzino's work. In the pictures that made him famous and sought after, those glacially elegant portraits of the Tuscan grand duke Cosimo I de' Medici and his family and of the Florentine patricians who buzzed around the Medici court, it's the accoutrements that first dazzle the eye, the intricate damasks and elaborate laces, the meticulously stage-managed props—medallions and cameos, classical statuettes and vellum-bound books carefully opened to let you see the sonnets within—that, often, seem more expressive than the sitters themselves. Small wonder. These were people less interested in revealing their private selves than in asserting their public status: the aristocratic sons of bankers eager to make sure we're aware of their literary enthusiasms, the trophy brides like Eleanor of Toledo, Cosimo's first wife, encased in their stiff brocades as if it were armor and clutching the infant sons who earned them the ropes of pearls that cascade from their slender necks.

If the faces are arresting, it's because they are part of the theater—masks rather than windows. Eleanor's dark eyes, as opaque as the fabric of her gown, give absolutely nothing away as they coolly stare us down; when the anonymous young black-clad *litterato* in the Metropolitan Museum's *Portrait of a Young Man* of the 1530s deigns to look at us, it's merely to suggest that we're unlikely to understand the contents of the book he's holding in his right hand, his forefinger marking the passage he was reading before we interrupted his leisure.

At first glance, it's tempting to dismiss the teenaged courtier Lodovico Capponi (b. 1533) as just another jaded member of the Florentine *jeunesse dorée*. The scion of a wealthy family, Lodovico was about sixteen when he sat for the picture. The youth is severely dressed in a black doublet with white sleeves, with just a bit of white ruffle peeking above at his collar; arrestingly, Bronzino has set him against an emerald-green backdrop, a silk hanging the richness of whose color seems intended not so much to set off as to mock the dour sobriety of the sitter. Green and white may have been the colors of youth, hope, and generation in Renaissance iconography, but there isn't much verve in this picture. The only organic colors are the pale pinks and ochres of the young man's hands—one clutching a pair of gloves, the other holding a cameo in elegantly elongated fingers—and of his sallow, unsmiling face. The light brown hair is fine, the brows elegantly arched, the line of the cheek slightly plump, the cupid's bow lips pursed; the hazel eyes, with their hooded lids, have a slightly hypothyroid bulge. It's a face you can still see in many a *liceo classico* in northern Italy today.

But something is wrong here; this mask has ever so slightly cracked. Look at the eyes again. No teenager should have those weary smudges, that downcast expression. Unlike the eyes of Eleanor of Toledo or of the disdainful young man in the Met's portrait, which meet ours straight on and, if anything, challenge our own right to be looking at them, Lodovico's eyes are averted, slightly downward and to the left, as if they can't bear to meet our gaze. Why not? The medallion may contain a clue. Partly obscured by the youth's hand, it bears the face of a woman and the legend *sorte*: "fate." And indeed, Lodovico's unhappy fate took the form of a woman. For years, he suffered for love of Maddalena Vettori, a young woman whose stepfather, a certain Salviati, refused to let her marry Lodovico; Salviati went so far as to shut Maddalena in a convent to keep her away from him. When the girl was finally allowed to emerge—in order to become the lady-in-waiting to Eleanor of Toledo—she was

permitted to show herself in public only on days of court processions through the city. Undaunted, Lodovico bought himself a palazzo along the processional route so he could glimpse his beloved. We are told that crowds of onlookers used to gather before the Capponi palazzo in order to witness the ardent looks that the two lovers would exchange—their only means of communication.

94 No wonder the youth in the portrait looks so weary; no wonder he cannot meet our gaze. He is tired of looking, tired of being looked at. However cool its palette, however much it seems to adhere to the marmoreal conventions of attitude and pose that Bronzino himself established so successfully, there is a dark emotion here. Fracturing, for once, the Florentine *disinvoltura*, a great wretchedness has broken through to the surface, where it now leaks out of those sorrowing, exhausted eyes.

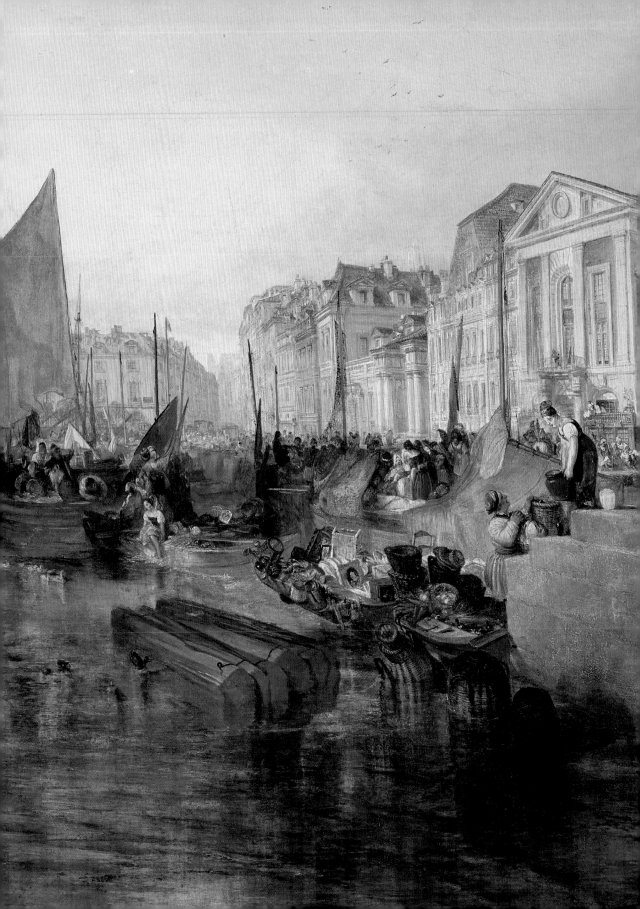

RICK MEYEROWITZ

Joseph Mallord William Turner, *Harbor of Dieppe: Changement de Domicile*, **exhibited 1825, but subsequently dated 1826**

That morning, we crossed the Channel from Dover to Calais, then drove south toward Deauville. In Dieppe, we sat at a cafe by the harbor. Behind us, the weathered facades of the buildings along the quai glimmered in the cold April light. The look of the place—the scale of those buildings, the wide street to our right, the old Hôtel d'Anvers behind us, the swaying masts and the fishing boats that filled the harbor in front of us—felt familiar, like a flickering déjà vu. Later, on the Grande Rue, we bought a toy tank for our son, then climbed the tower of the Église Saint-Jacques and looked out over the city while the boy aimed his Panzer IV down at the pedestrians on the Place Nationale and out toward the beaches, where, in 1942, real panzers fired on real Allied soldiers.

His mother, pointing to the clouds scudding in over the Channel, said they reminded her of a painting by Turner. Turner! The answer to my déjà vu handed to me on a silver platter should have been a eureka moment, but it wasn't (perhaps she should have hit me on the head with the platter). Instead, months passed before I realized that Dieppe was the town in my favorite Turner painting.

The two Turners in the Frick's West Gallery have dazzled me since I was a teenager. I love his painting of Cologne at evening time, with its gorgeous sky and pellucid green water, and the sails on that boat, and the red buildings, and the blue-shadowed gateway, and that little dog in the foreground drinking it all in. But I am completely crazy for his *Harbor of Dieppe*. Why do I prefer this one over the other?

Harbor of Dieppe is a cinematic painting. The deep space conjured by Turner pulls me into the painting and up over the water to the distant dome and tower of Saint-Jacques, or onto the quai, where I imagine myself as part of the crowd flowing toward the Grande Rue. To my left, a thousand masts sway in the breeze. To my right, the facades of the old buildings bask in the warmth of Turner's light. Everywhere the scene teems with life: with drinking and kissing and haggling and eating and selling wine and fish and clothing and plates and chairs and baskets and pictures. Two grenadiers on horseback share a joke. Someone shakes out a towel on the balcony of the (yes!) Hôtel d'Anvers. In the water, a family of ducks paddles past a woman cooling her feet. Pigeons take flight from a rooftop, and high above, gulls circle, their wings lit by the sunlight on Turner's brush.

It's been many years since that day in Dieppe. My son, now grown, remembers the tank but not Dieppe. I've been back to France many times but only return to Dieppe and walk its streets when I see Turner's painting at the Frick.

After a recent visit to the Frick, I took the subway downtown. I walked along, thinking of the painting and how I'd often imagined what it would be like to walk on Turner's Grande Rue. A bus roared by, waking me from my reverie. I looked up. Under a vivid blue sky, I saw the northern side of the street was ablaze with a golden late-afternoon light. Turner, I thought, would have loved this street right now. And it came to me then (without my being whacked with a platter) that if I really wanted to walk on a Grande Rue, I need look no further than the sunlit New York street I was already on, the one I walked every day: Grand Street.

DUANE MICHALS

Jean-Antoine Watteau, *The Portal of Valenciennes*, ca. 1710–11

Soldiers at Ease, Reflections on Watteau's *Portal of Valenciennes* I still remember it quite clearly. Our armor 99 column had arrived late at night to bivouac. We were on spring maneuvers in Bavaria. The men were exhausted, and Charlie Company hardly seemed ready for combat. We positioned our tanks in the velvet blackness, and I had not noticed where we were. I was awakened by the first sliver of dawn light, defining the crest of the surrounding knolls. The tanks sat nestled in a small valley, a road bisecting it. On the right was a pine forest, lush in its saturated greenness. The floor was covered with a mossy cloak. I had never seen so many subtle shades of green, which when struck by the morning sunlight, glistened with dew. The other side of the road was carpeted with yellow leaves amid a forest of naked birch trees, a yin and yang of alternating colors. Sprinkled among these trees were the tanks, like black polka dots. Suddenly the sound of a single cuckoo bird echoed in the valley, then another, then another. The men were loitering half-awake outside their tanks, drinking morning coffee, waiting for orders, and reading letters from home. The army in repose.

What a surprise then, when I serendipitously discovered *The Portal of Valenciennes* by Jean-Antoine Watteau. The small painting was hiding in a corner, near a window with a view of the Garden Court, as if shy when surrounded by the heroic scale of the Frick's celebrated collection. I recognized it to be him, the master of luxe, but hardly what one expected. It had all the classic intimate taste of the *haute société*—lavish in their silks and lace at play. He turned the *bois* into a theatrical backdrop for their *fêtes galantes* of privileged pantomimes and graceful loitering. I hear the silent music implied by the guitarists and singers. Everything is a gesture of romance and very alluring indeed.

In this painting, Watteau brought his signature charm to an unusual subject: ordinary soldiers at ease, hardly the French grandees frolicking. He now focused all attention on the lowest rung of the military ladder. I wonder what drew the artist to this milieu. What instincts prevailed upon him to notice these clumps of infantrymen? It could not have been purely the pleasure of depicting military uniforms. What sympathy of a different sort was the common denominator that connects the *soldat d'infanterie* with the aristocrats? The question tantalizes.

I know why I identify with this tableau so dearly. It brings to mind that early morning in Bavaria so many years ago, when I was a green second lieutenant fraught with lassitude and loneliness. There is a camaraderie among men who have served in an ambience of anxiety and apprehension of the potential horror of combat. Young men wait and are always robbed of their youth by old men. I can imagine the foot soldiers of the Roman legions, the Confederate infantry near Appomattox Court House, and the English Tommies in World War I sharing this duplicate familiarity. The stain of memory still lingers. Oh Monsieur Watteau, how grand this little painting. *Merci.*

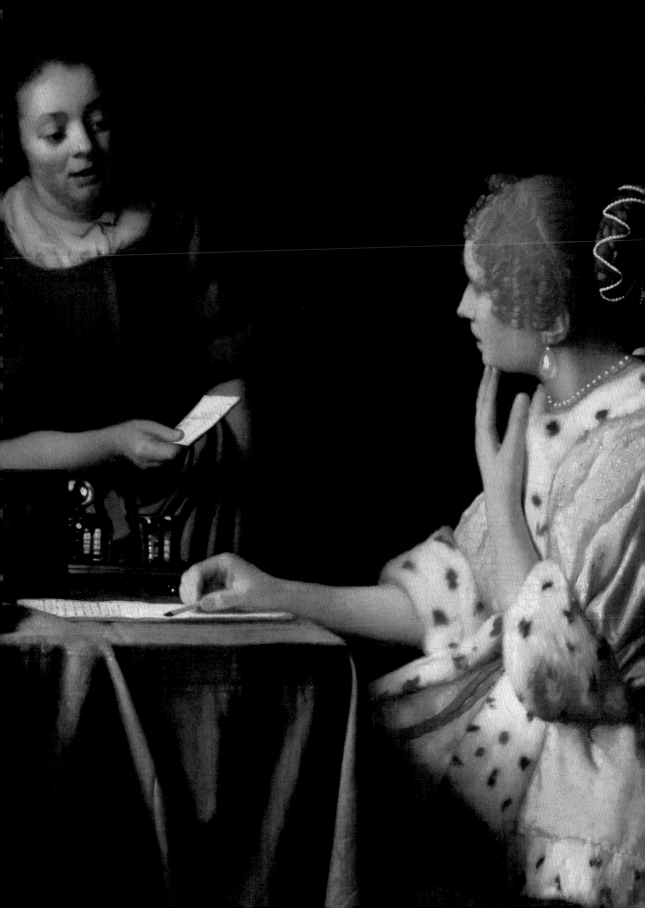

SUSAN MINOT

Johannes Vermeer, *Mistress and Maid*, 1666–67

Vermeer—The Order of Impressions When viewing a painting, impressions come in an order. Another viewer of this Vermeer might see first a cupped hand beside a pen on a blue tablecloth, the accent of orange in the stripe on the seated woman's lap, or the voluptuous black-dotted ermine trim of her dress. My first impression of the painting, with its entrancing light and pensive mood, is of the letter hovering between the two women. Then I am intrigued by the seated figure's coil of small pearls zigzagging on a donut-shaped bun at the back of her head. A fat pearl hangs by her throat. Her hand is in an unusual pose; two tentative fingers barely at her chin, which alongside the thumb, make a black negative space nearly the same shape as the letter, the whitest spot on the canvas. The letter is held uninsistently by a woman with deferential but fleshy eyelids. The title is not *The Letter*, as one might expect, but *Mistress and Maid*, highlighting their relationship. As with every great painting, the longer one looks, the more one's impressions shift, steep, intensify, ranging from the trivial to the deep.

How long must it have taken the mistress to get dressed? Her skin is pink-white; the maid's a more swarthy tone of the physical laborer. How long did it take Vermeer to paint it? Interesting those yellow pleats in the shoulder of her dressing gown. Vermeer made only thirty-six paintings and limited his settings to what were apparently two corners of his house in Delft. One wonders if this is the same pearl as in *Girl with a Pearl Earring*.

I start to sketch the mistress's profile. Only the smallest sliver of her face is revealed, like a new moon. The expressive worry in her mouth and concern in the glancing look of her eye is unmistakable. She puzzles over the letter.

The maid in a skirt, white shirt, and brown wool frock (not needing long to dress), looms out of a cavernous black background that reads as eternity crossed with a stage set. The center of the painting is a black hole. The maid's expression is not so much subservient as simpatico; she, too, has concerns about the letter. Has the mistress just written the letter, and is the maid wondering where she should take it? Or is the maid checking that the mistress really wants to deliver it, and now the mistress is reconsidering? Maybe the maid is right—she should not deliver it. Or maybe the maid has already tried to deliver it and the addressee was gone. Or the letter has been strangely returned, unopened, puzzling them both. Or, the letter is from another, and the maid is gently describing who it's from or the strange manner in which it has arrived.

Regardless, the two women, separated by their stations in life, are transcendently united in their concern. It is as if they are contemplating the eternity of the universe, two luminous bodies connected by a white flag, while at the center of the canvas remains the black hole.

MARK MORRIS

Duccio di Buoninsegna, *The Temptation of Christ on the Mountain,* 1308–11

"Someday, all of this will be yours!" So says the seductive superhero Lucifer.

This picture is a thrilling and efficient presentation of the taunting of Jesus by the Devil. I don't see any evidence of the "change-this-stone-into-bread" challenge, but I certainly get the "all the wealth, power, and control in the world are available" and the "trust me . . . make the leap . . . those-angels-will-be-there-to-catch-you" trick. After those forty terrifying days alone, who wouldn't be tempted to do something desperate and stupid by such a randy and charcoal-black Satan? It happens all the time.

Apparently you can't fool Jesus. The majestic, confident, elegant Christ is huge in comparison to the tiny city-states in his far distance, which is actually our foreground. The beautiful, calm, empty, proud structures could easily be an under-the-Christmas-tree miniature train set, minus the Christmas tree and the trains. Where are the tiny automobiles? Why are the buildings made of pastel fondant? They look delicious. Is Jesus wearing one of his mother's blue robes? Is there a wind blowing? The imaginary mountain that the tired and hungry Christ stands on, if viewed from behind, is a Potemkin village of lumber, chicken wire, and papier-mâché. Is there a tinier raging river anywhere?

Let the art historians take care of the provenance and the context and the "meaning." I'm pulled into this gorgeous fragment of praise and lesson by the wild mix of distances and chronology and tension—and pushed away by the overwhelmingly lustrous slabs of gold. So moving and casual and quotidian. I needn't look for contemporary "relevance" in the symbolism and magic of this panel. It is exactly here and now. Like all the best art.

NICO MUHLY

Duccio di Buoninsegna, *The Temptation of Christ on the Mountain*, 1308–11

Duccio's strange and enigmatic *Temptation of Christ on the Mountain* was designed for a sacred context. Of course, it is a fragment of a much larger altarpiece, the *Maestà* in Siena; looking at the decontextualized piece, on the Upper East Side rather than Tuscany, is like listening to a piece of church music in a concert hall. It is, however, an opportunity to perform a close reading of a beautiful object approximately the size of a piece of manuscript paper.

Confronting the panel reminds me of walking into a movie at the end or coming face-to-face with a barely solvable enigma like one of Cindy Sherman's photographs. We are invited to engage not just with the moment, a vertical simultaneous chord, but with the backstory of how we got to this extreme composition, with its concurrent registers of architecture, theology, clothing, and perspective. Speaking musically, I would describe its narrative as both frozen and busy—a beehive, in a sense, which remains stationary despite a sense of constant economy, at once covert and obvious.

To the modern eye, there is something marshmallowish about the colors of the panel's cities of the world, here modeled on Siena. Parts of Siena, even (if not especially) in real life, look like the ruins of a Lego citadel, smashed by an angry child's foot or inadvertently knocked over by a dog—in some way scrambled rather than organized. There are five (or arguably six) distinct cities in Duccio's panel: beautiful handfuls, almost disposable in their quaint finiteness. The implication almost seems to be that Jesus is saying that he'll come back for those later. When Satan tempts him with the idea of turning stones into bread, Jesus references the bread with this rejoinder: "Man shall not live by bread alone, but by every word that proceedeth out of the mouth of God." On the mountaintop, when the Devil promises him all the cities and the riches of the world if only he will bow down before him, Christ reverses the formulation, saying, "Get thee hence, Satan: for it is written, Thou shalt worship the Lord thy God, and him only shalt thou serve." It's a much more explicit reversal than the verbal sidestepping Jesus does with Pilate or Herod Antipas.

The hair's breadth between Jesus's robe and a thin turret suggests that if he were to just loosen his grip, the garment would expand to envelop the city and the top of the mountain, fulfilling the prophecy in Isaiah: "And it shall come to pass in the last days, that the mountain of the LORD's house shall be established in the top of the mountains, and shall be exalted above the hills." Duccio constantly plays with perspective, but this particular panel seems to take a sly theological approach in addition to an artistic one: Christ's sure-footedness versus Satan's unsteady right talon, struggling for purchase, is achievable because the mountains are *already* made low. Or perhaps they are low places made high. We've fast-forwarded and fulfilled another of Isaiah's prophecies: "Every valley shall be exalted, and every mountain and hill shall be made low." The fantastic parallel lines between Christ's robes and the rock formations reinforce this harmony between his raiment and prophecy. In this sense, the energy of the entire right-hand side of the panel is forcing Satan out of the frame; Christ's finger is just a bowsprit of an enormous repellent structure. Here, again, there is a musical architecture: the small lines of what seems like ornament make up an aggregate of enormous power. This, for me, anticipates the Baroque but also a much more contemporary, almost cinematic, sense of the power of detail and constantly shifting perspectives.

This moment of the Devil showing Jesus the kingdoms of the world is tricky to represent. The hyper-realistic versions from say, Mormons and Jehovah's Witnesses, feature dazzlingly Caucasian protagonists in relatable, NASCAR-dad poses. In Duccio's version, there is a hidden and subtle sense of the infiniteness of these little fortifications: as the mountains and distant cities fade into obscurity, do we not imagine additional such towns, stretching into the distance? Yet, our focus remains on the details of the present moment: with one hand stretched toward an especially picturesque brick entrance, the Devil, even as he leaves, makes one last desperate attempt to bargain with Christ.

The way Jesus's halo, with its enigmatic diapering pattern, nearly grazes the top of the panel is thrilling to me. It allows Duccio to create an unnerving sense of infinite cities and wonders without the need to set the scene literally; the halo's circle is completed by the trim on Christ's collar, suggesting a future poetry of theological completion.

The music of this panel comes from its percussive resistance to depicting a single moment in a story. Every point on which the eye can rest contains a line and the counterpoint to the same line, all played at once. It's simultaneously generous, inviting, oblique, and precise.

VIK MUNIZ

Jean-Étienne Liotard, *Trompe l'Oeil*, 1771

The Age of Enlightenment brought forth a renewed trust in sensorial experience as a fundamental source of knowledge. In this climate infused with empirical thinking and scientific research, artists conjured their own logic about the world they so carefully contemplated. As experience gradually took the place of superstition and dogma, they found, in the new thinking's reliance on perception, something they had already known for a long time and were deeply encouraged to explore further. Trompe l'oeil and still-life painting coalesced into genres that challenged their competence to technically describe what was in front of them. Some took the challenge as a life mission; some, like Liotard, just flirted beautifully with the subject.

Liotard was one of the most eccentric artists of the Enlightenment. His signature pastel portraits brought him renown and important commissions that enabled him to travel all across Europe and the Near East. His portrait of a self-assured ten-year-old Marie-Antoinette of Austria, future queen of France, seems to prefigure her royal future as she stretches a segment of sewing thread that will take her straight to the guillotine twenty-seven years later. In another notorious work, Liotard paints himself, a sixty-eight-year-old man jokingly smiling with gapped teeth while pointing to the outside of the frame. Smiling self-portraits are an anomaly in the genre of Enlightenment portraiture. Following an extended stay in Constantinople, Liotard adopted oriental costume—plus an unusually long beard—that earned him the nickname "The Turk." He only made ten trompe l'oeil works during his long and successful career, and the one at the Frick is one of my favorites.

The Turk thrived in a world of perceptions, in the primordial glue joining physical and imaginary things. His subjects materialize an unflinching regard for observed reality, simple and magical as a card trick, a reality that seems overdependent on illusion in order to manifest itself. There's also a sense of a semantic architecture, a layered narrative that takes the willing observer into the potential universe only a flat image can conjure. *Trompe l'Oeil*, a beautiful jewel of a painting, offers the eye a series of self-canceling visual propositions that never stray from the overall verisimilitude of the image. Wood, paper, plaster! A different reading wins each time I look at it. And the Turk laughs, presenting the viewer with a reality that is neither mental nor material. That's what the great artist is pointing at.

WANGECHI MUTU

Unknown artist (Mantua?), *Nude Female Figure* (*Shouting Woman*), **early 16th century**

The *Nude Female Figure (Shouting Woman)* is a small bronze sculpture from the Mantua region of modern-day Italy. At the time of its creation during the 1500s, the area was known for its excellent theater and opera. This tiny artwork carries across the centuries, across the seas, quite a melodramatic punch. Despite its modest ten-and-a-half-inch height, it has significant power and pull. It is very delicately made, explicit, and theatrical.

This piece is not only rendered wonderfully, it has a narrative quality that expresses so precisely the trouble or crisis that has befallen this woman. It could be inspired by the story of a particular woman's violation or the Book of Genesis and the banishment of Eve from the Garden of Eden.

I am utterly fascinated by this figure from more than five hundred years ago that is not statically posed but in a position that reveals rather than conceals something about her. I am curious about how troubled she seems and how she's responding to something or someone right beside her.

She's active, uncomfortable, expressing herself, communicating her shock and distress, her fear or shame while covering her genitals and her breasts and preparing to flee. I am captivated by the title because it suggests that she communicates this distress through her voice. She has a voice, even if we cannot hear it. The sculpture, for me, is an expression of the artist's concern for this woman and, by extension, for all women. She is naked but aware of it; she is shouting out but also protecting and concealing. I dare say this may have been sculpted by a nimble-handed artist with humanity. Someone with a sensitivity and a genuine interest in the predicament of a lone woman fending for herself and her honor. For that, I am impressed, because half a millennium later, I can feel the power, the advocacy, and the poetry in this one single act.

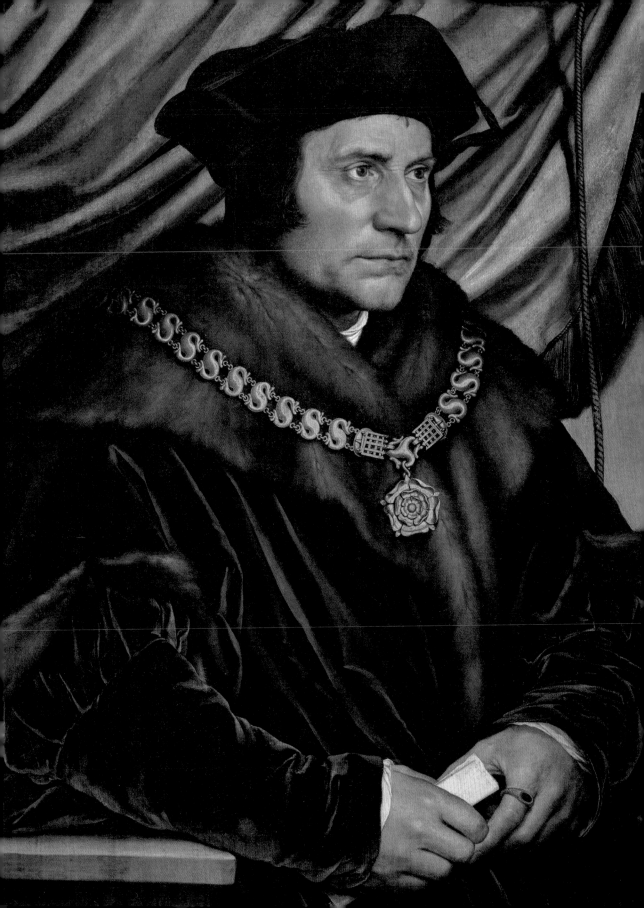

CATHERINE OPIE

Hans Holbein the Younger, *Sir Thomas More*, 1527
Agnolo Bronzino (Agnolo di Cosimo), *Lodovico Capponi*, ca. 1550–55

In thinking about work that I gravitate to at the Frick, I had a hard time choosing and decided to write about two paintings— Holbein's *Sir Thomas More* and Bronzino's *Lodovico Capponi*. I often think of these two as hanging side by side. In fact, I hung posters of them that way in my home studio in the 1990s, when I was making photographic portraits of my community. Placed on the left is Sir Thomas More—as if looking at Lodovico Capponi. The paintings share visual traits that I go back to time and time again: each figure is holding something of importance, and the fabric backgrounds are almost the same shade of green.

The outward gaze of each sitter allows the viewer to look at him without meeting their eyes straight on. Holbein and Bronzino painted with a formality and an attention to detail that invite you to look closely at every brushstroke. The painter's control of the brush, in my view, is closely linked to the photographer's control of the lens; both consider how light falls onto faces and fabric.

When looking at any portrait, my eyes always focus on the hands and what, if anything, they are holding. In these paintings, the significance of what the subjects are holding is as much a part of their identity as are the markings on the body in my own portraits.

In the portrait of Lodovico Capponi, which I always refer to as "the boy with a codpiece," Capponi's hand is delicately holding a cameo, perhaps of a loved one, connecting the paintings in another way: Holbein was known for his miniature portraits of possible brides for Henry VIII, a brutal king who beheaded Sir Thomas More, as well as his wife Anne Boleyn.

Great portraits like these create the desire to know something of the history of the time. The painting of Sir Thomas More was commissioned in 1527, twenty-three years before Bronzino painted his portrait of Lodovico Capponi. I often wonder, when visiting these two works, if Bronzino knew of Holbein's work and, specifically, of the portrait of More.

It is my own queering of these two pieces to hang them side by side, staring up at them as Sir Thomas looks over to Lodovico. But most important is how these works always stay with me in my mind's eye when I am making portraits. For this, I am forever grateful that I can visit them in person at the Frick.

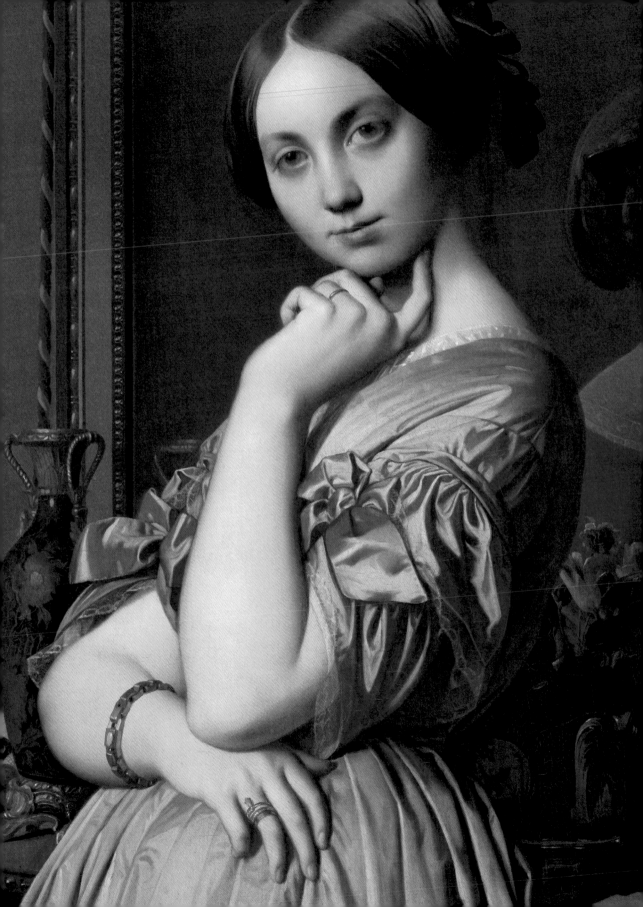

JED PERL

Jean-Auguste-Dominique Ingres, *Comtesse d'Haussonville*, 1845

The imperturbable surface of Ingres's portrait of the Comtesse d'Haussonville is perturbation incarnate. Where to begin? With the hands that suggest two five-legged octopuses? Or the doppelgänger dark reflection of her head in the mirror? In his own day, Ingres was loved, hated, feared, and revered for upholding an adamantine idea of tradition. But in his greatest works, classicism becomes a romantic dream to be pursued with the meticulous eye of a realist. Ingres gives the porcelain shimmer of nineteenth-century academic painting a subversive double life. Nature, microscopically observed, becomes surreal.

Louise d'Haussonville was a cultivated woman, a talented pianist who had studied with Chopin, played Bach and Handel, and made a number of drawings inspired by Verdi's *La Traviata*. Her magnetic presence both confirms and confounds Ingres's seamless composition. She is the indomitable protagonist and, in that sense, kin to the gifted nineteenth-century singers and dancers who brought *La Traviata*, Tchaikovsky's *Sleeping Beauty*, and any number of other theatrical masterworks alive on the stage. There is something musical, balletic, operatic about the slow-building column of her exquisitely rendered blue silk dress, a fantastical display of luxurious fabric that supports the adagio beauty of her bare arms, bent fingers, and tilted head. Ingres's portrait is less a commission than a communion. Like the heroines in the novels of Tolstoy, Flaubert, James, and Proust, she is engaged in a never-ending dialogue with her creator. Artist and subject grant each other immortality.

Ingres was a virtuoso. But nobody knew better than he that virtuosity was a trap. Degas recalled that the older artist instructed him to "draw lines, young man, draw lines." Ingres's impassioned feeling for the abstract power of line and form frees this valentine to nineteenth-century beauty and sophistication from the taint of timeliness. Here everyday and eternity meet. The objects on the mantelpiece—the vases, flowers, opera glasses, and visiting cards—are realized with an almost scientific attention to detail. Light years separate this surgical anatomization of an elegant Parisian still life from the idolatrous idealization of the aristocratic woman's head. Her eyes, like the eyes of a goddess, give nothing away. As for the colors that Ingres has brought together here—a steely blue, with touches of red and yellow, all set against a harmony of blacks, whites, and grays—they could as easily have been orchestrated by Mondrian.

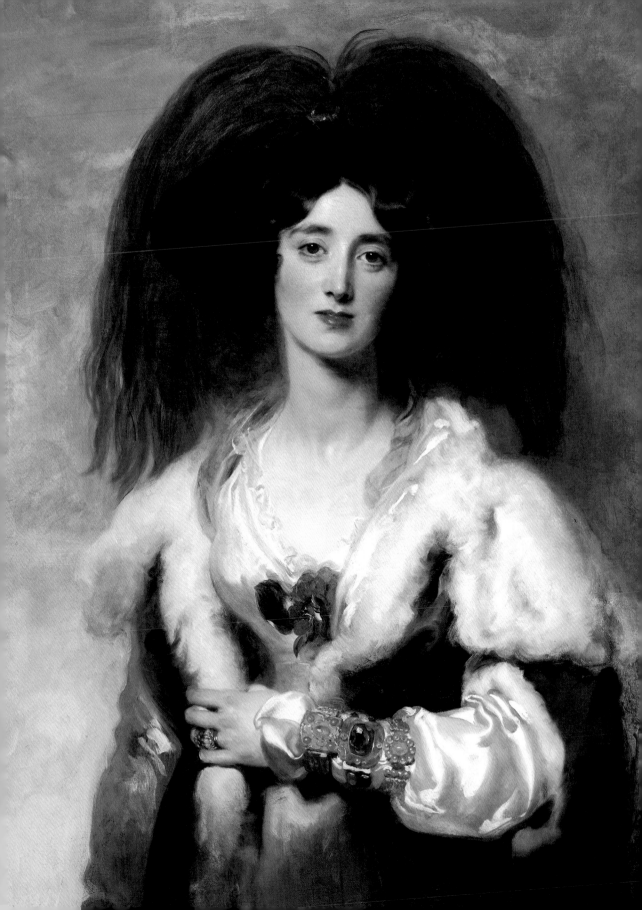

TAYLOR M. POLITES

Sir Thomas Lawrence, *Julia, Lady Peel*, 1827

This woman. I never looked for her biography or the circumstances under which her portrait was painted. Everything I needed to know was on the canvas. The flare of red feathers from her hat. The rich satin of her dress. The row of gold bracelets studded with precious stones. The rings. The fur. The beautiful face, gently tilted, rose in her cheeks. The soft brown eyes, gazing out with sweetness but something more. A little sadness in them. A longing. How I felt that longing too. That sadness just under my skin.

I first saw her when I was in my early twenties, new to Manhattan, full of yearning, perhaps fear, definitely uncertainty. So much desire, so much aspiration. The Frick Collection was a revelation of refinement, of richness and sophistication. I became a member of the museum—the one membership I could allow myself as a young person struggling to make it in New York. Being a part of the Frick was to strive for the pinnacle, the *ne plus ultra*.

A staggering mountain of wealth, extracted from the oppressed, built this temple to western culture and exquisite good taste, the aspiration of a ruthless capitalist. The legacy of that life is this dreamworld, frozen in time, the accumulated relics of lost worlds arrayed in a Xanadu of the Gilded Age. A palace of dreams and dreamers, its bloody roots buried, where the young and confused come to lose themselves in the wistful sadness of a beautiful woman dead two centuries ago.

I stood for hours before the portraits, in the quiet luxury of the rooms, with overstuffed sofas of green velvet trimmed in gold braid, silk lampshades with filigree fringe. Ingres. Bellini. Holbein. Whistler. Gainsborough. And Lawrence's *Lady Peel*. Those beautiful sad eyes. That longing.

Twenty-five years later, I see her again, and she has not changed. In her eyes, I see myself, that young man, that boy in his heart, fearful, yearning. We know each other, Lady Peel and I. We gaze into each other's eyes. We see the sadness of our never-ending desires, of the aspiration just out of reach, regardless of the achievements of our past, the richness of our present. There is always something more to seek, something to regret, to remember and wonder what if.

A twisting path led me back to the Frick to stand before her, older, wiser, but still the same, a boy in my heart, with so much longing unfulfilled. We will know each other when we meet again, Lady Peel and I, but who will I be then? What will I see reflected in those beautiful brown eyes? What solace will I seek in this exquisite dreamworld?

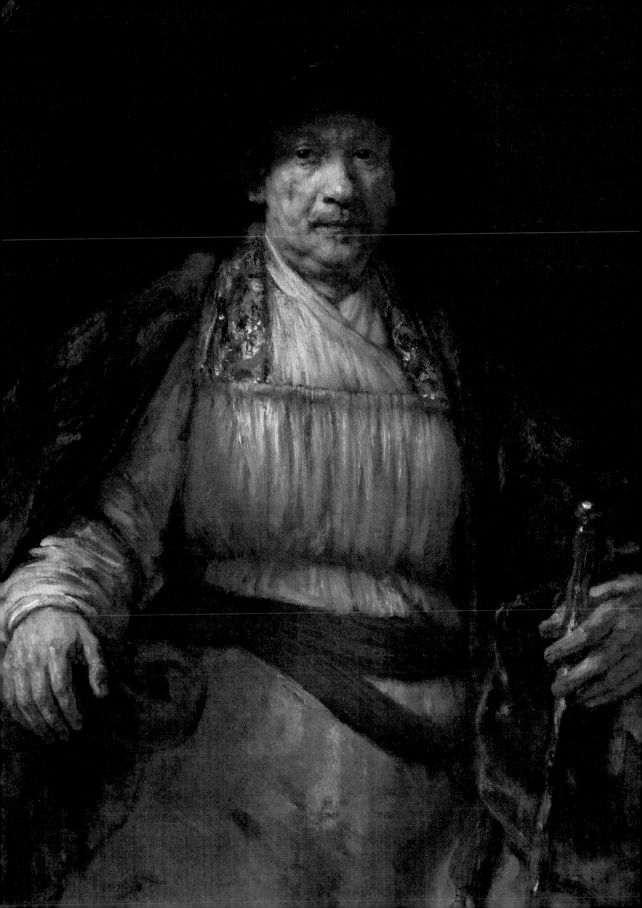

DIANA RIGG

Rembrandt Harmensz. van Rijn, *Self-Portrait*, 1658

On every return to New York, I make time to re-visit the Frick. It is unique in that it is the only museum to retain an atmosphere of the grand residence it once was. However, the real reason I go is to make a pilgrimage to see the Rembrandt self-portrait I first saw as a young actress. I recall standing before it, admiring the mastery of Rembrandt's brushstrokes, noting that nothing unnecessary was present; the simplicity and truth of his approach was a lesson in artistry that transcended the barriers among all disciplines. I remember thinking, "That is how I want to act." Learning this lesson was one thing, putting it into practice quite another. I think I am getting there. Gradually.

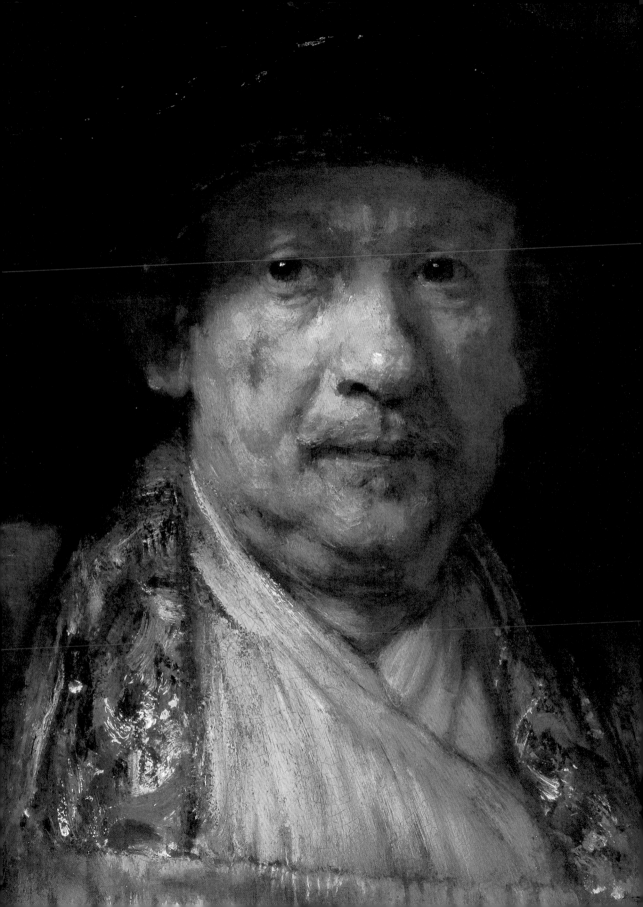

JENNY SAVILLE

Rembrandt Harmensz. van Rijn, *Self-Portrait*, 1658

In Praise of Shadows. I try to look away. To look at a different picture when entering that illustrious room in the Frick and to give a different painting a chance. But the magnetic force of the Rembrandt pulls my eyes over, however much I try to resist its powers. It's the Rembrandt, it's him in his half shadow from the black hat. King of the room. King of painting. King Lear.

Not many painters are good at half shadows. Velázquez is. Caravaggio too, but his forms get lost in darkness. Not so with Rembrandt. He knows that poetry and mystery lie in the transition of shadows. And with shadow comes that anointing light that guides our sight.

The passage of light that starts right on the eye, dripping down his thick, battered cheek, over the gold tunic, the red sash, and pooling on the landscape of his elegant, gnarled hands. It's like a long shot in cinema when the camera drifts over forms. But he does it in paint.

SIMON SCHAMA

Joseph Mallord William Turner, *Mortlake Terrace: Early Summer Morning*, 1826

Mortlake Terrace: Early Summer Morning never fails to hit me with a keen stab of longing. The limpid light washing the scene is the light of my memories, the happy ones anyway. Turner was a Thames river brat, and, born 170 years after him, so was I. As a child, Turner was taken to live with his uncle at Brentford, and there he began to draw, so that light, sky, and water were always an indivisible chain of sensation. When he painted the river flowing past William Moffatt's suburban villa, he was himself living not far away at Twickenham. He was in his fifties when Moffatt commissioned him to produce this picture of his idyll, but he had been experimenting for decades on liquidating (I use the word advisedly) the boundary between watercolors and oils—between what was sometimes regarded as the medium of amateur gentility and that of the professional painter. In 1805, he had taken to the Thames to sketch, on canvas and panel, while actually afloat on the stream, and those sketches encompass a miraculously experimental range of textures from dense to airy. The Frick painting, like its "Evening" pair in the National Gallery in Washington, thins out the pigment so that it seems to be floated or breathed on to the canvas: a scrim of blonde light flooding everything, turning the quotidian moment into a paradisal beginning of the day.

Rivers coursed through Turner's sensibility like blood; he spent time in France and Germany sketching the illustrations for tourist books. But the Rhine and the Seine were operatic romances; the Thames was the site where history, personal memory, and the fugitive idyll of English life flowed together. It's the necessary hero of his grandest visions: *The Fighting Temeraire*, and *Rain, Steam and Speed*, both visual poems on the caprices of time. But he also sketched the serpentine meanders of the river from high on Greenwich Hill, as it snaked through the clotted throng of London or lit with incandescent fire on the night when Parliament burned down.

But the Frick painting is in an intimate key, one where landscape and genre melt together in that dewy morning radiance. It's a busier picture than it seems at first sight: a racing boat is out for practice (Mortlake is synonymous with the finish line of the Oxford-Cambridge boat race); the odd wherry and barge are at work; Moffatt's gardener has already been cutting the lawn and is sharpening his scythe to finish the job before the summer sun makes the labor too hot; there are signs of drowsy ease; a besom lies on the grass; a wheelbarrow awaits the sweet-smelling trimmings; the "Limes" (or linden trees) that gave their name to Moffatt's house, spread like parasols out of their pollarded length of trunks. And at the end of the little avenue, two men, perhaps the rich brewers, stand in easy conversation: one with his face to us, the other leaning as one would over the low wall watching the shift of silvery water. An opening leads down to the implied dock.

It is 1826. Somewhere in England, there are millworkers, toiling in dirt and darkness; somewhere in England radicals are fuming at the brutal arrogance of the aristocrats who own land and much of the British constitution with it; the king is a bloated hulk of indolent vanity. Byron had died of sepsis at Missolonghi; Wordsworth and Coleridge were in reactionary retreat. But at Mortlake, for one morning, a numinous light lands on a scene of perfect sweetness with the delicate intensity reserved for dreams or the passing vision we all hope to catch and keep all our lifelong days.

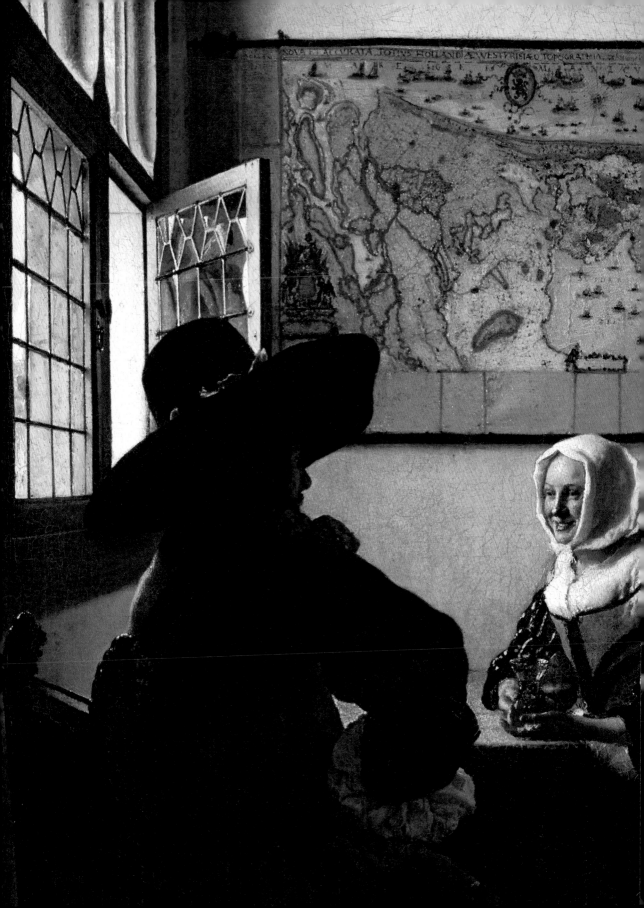

LLOYD SCHWARTZ

Johannes Vermeer, *Officer and Laughing Girl*, ca. 1657

Officer and Laughing Girl

"Who is this man? I can barely
make out his face in the window-glare.
A fierce silhouette. The glowing edge
of his floppy, broad-brimmed hat—
the Devil with a halo! His
red jacket on fire. An assault
of maleness; a mystery . . .

Does he see my terror?

—Or is he staring at the map
on the wall behind me? Or out the
open window? His impatient hand
on his hip, even sitting down.
What does he keep staring at? What
makes him stay?"

$$\approx$$

"Why doesn't she just drink her wine
and relax? She looks like she's
about to cry. I can see the tears
welling up. But no—her eye
is clear. Her hands on the table,
around her glass, palms up—ready to take
whatever is given . . .

What do I have to give?

—I could travel past the edge
of the known world, and never find
a pearl worthy of this smile
that sees right through me,
sees my darkness—
yet doesn't cease to smile."

When anyone asks me where I grew up, I say that while I lived in Brooklyn and Queens, I grew up in Manhattan on the weekends. Those trips into "the city" with my two closest college friends of course included the Frick, which became a virtual home-away-from-home—not only a place for looking at paintings but also a fabulous

background for our tumultuous exchange of ideas and feelings (our conversations still include indelible recollections of where the paintings were hanging when we first started going there).

The painting that most captivated me was Vermeer's *Officer and Laughing Girl* in the South Hall (one of the few paintings that hasn't changed its position in all these years). I was immediately enchanted by the girl's smile. Smitten. But I didn't think she was laughing at all. That smile seemed to me to be hiding some great sadness or anxiety, the title of the painting hiding an inwardness more obvious in other Vermeer figures, which seemed to connect to my own emotional turmoil.

Everything here seems stable, yet like the girl's smile, the illusion of stability creates unease, mystery. Everything surrounding the girl in this light-filled room points outward: the shadowy officer in his hat and flaming red jacket, only visiting; the map on the wall; the open window reflecting the unreadable outside world. Are there more beautiful or poignant windows in all of Vermeer?

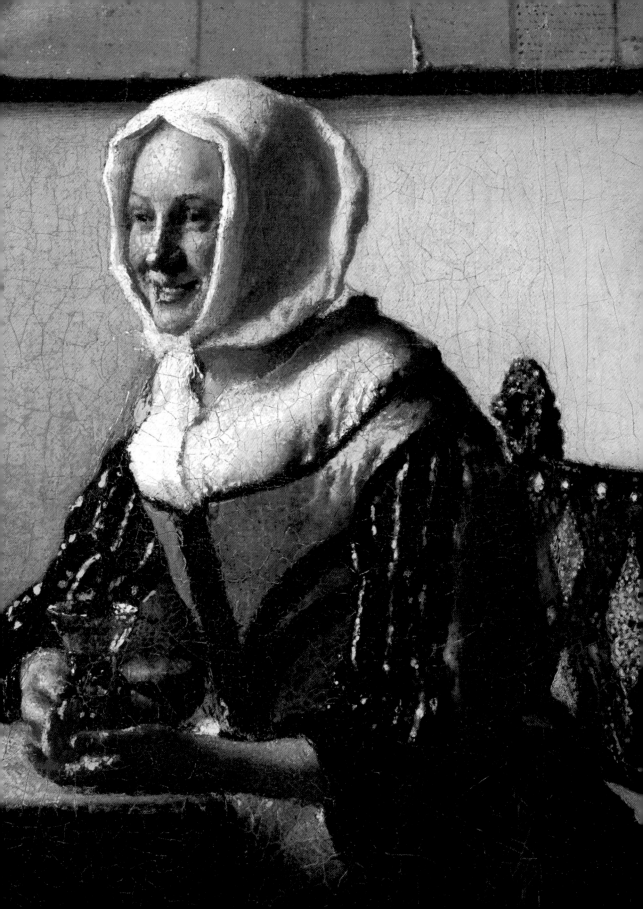

ANNABELLE SELLDORF

Agnolo Bronzino (Agnolo di Cosimo), *Lodovico Capponi*, ca. 1550–55

For many years, Bronzino's portrait of Lodovico Capponi has held a special fascination for me, and it remains one of my favorite paintings in The Frick Collection. I visit it every time I am there.

The picture is a large vertical oil painting on panel in a beautiful gilded frame, and the figure seems almost larger than life. It used to hang on the south wall of the West Gallery at the western end of the room. It struck me then that this impressive portrait of a young man felt lonely in this position. It was placed among a long row of wonderful paintings yet seemed isolated and apart. Today, the painting is on a limestone wall in the hall just north of the magnificent staircase. There, the unique presence of the aristocratic young man seems to me more at ease.

The figure is standing in front of a vibrant green cloth, the color of which is so intense that it is unforgettable. The green is memorable but so are the distinct folds of the ample fabric balancing the centered pose. The young man looks out into space, not looking at the viewer yet curiously aware of the viewer's presence, as if following you when you change your position. Lodovico is tall and handsome with the firm young skin of a boy. His hair is curly and reddish blond; it seems just cut. The expression in his oval face is still and serious, perhaps pensive. His blue eyes are such that one might wonder if he is ever so slightly walleyed.

Lodovico's expression is at once very personal, almost tender, and aloof, remote, and idealized. He seems to wear a kind of uniform, a black vest and white shirt. The details of his clothes are so minute that one might almost feel the surface of the material, every last velvet bead and embroidery on the vest and shirt. Lodovico wears a codpiece—a stylish accessory at the time—a kind of demonstration of male prowess. His long left arm hangs by his side, his hand holding a pair of gloves; but the other arm, held up close to his body, shows the right hand—a hand so elegant and long in truly Mannerist fashion—holding a cameo. Apparently, the cameo reveals the inscription *sorte* (fate or fortune), which, alas, I have not been able to detect. I learned that Lodovico was a page at the Medici court in Florence in the 1550s and fell in love with a girl whom Duke Cosimo had intended for one of his cousins. After nearly three years of opposition, Cosimo suddenly relented, but he commanded that their wedding take place within twenty-four hours. It is not known whether the portrait was painted before or after the marriage or whether the cameo is a reference to the girl.

I continue to be riveted by this painting; the more I try to think about what it is that holds me so—the beauty and perfection, the incredible poise, the colors, the detail and masterful skill—the more I think that it is ultimately the simultaneous quality of utter impenetrability paired with a provocative invitation to enter, to speculate, and to lose oneself in the ambiguity of the portrait.

Paintings and other works of art are almost always created as individual, unique objects, but the context in which we see them is part of our experience and memory. Often, we see them in more neutral museum contexts, but the quality of the building of The Frick Collection brings expanded meaning to our perception and connection to the works on view. Art informs the space, but the space also informs the art. And even though Lodovico might not always be in the same location, his commanding presence will determine where he is best seen.

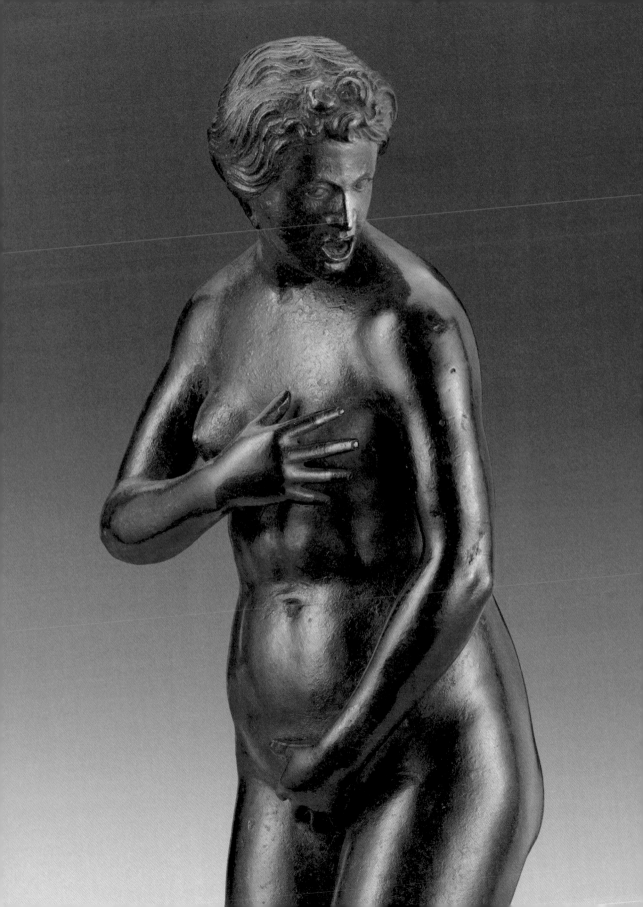

ARLENE SHECHET

Unknown artist (Mantua?), *Nude Female Figure* (*Shouting Woman*)**, early 16th century**

She's turning and fleeing but stops me and holds me at the edge of the glass case at the border of the Enamels Room. Tucked away and stilled through the centuries in cast bronze, she remains entirely active: open-mouthed, enraged, shouting. I hear her. Danger is lurking; she just escaped. This violated woman shields her sex and breasts with elegant arms and fingers. Every centimeter of this sculpture is exquisitely wrought and perfectly proportioned. Her toes are precisely bent, and every strand of hair is sublimely mussed; remarkably, we can even see her teeth. As a nautilus, compact and open, coiled and turned, a spiral of (female) energy, she blows up the stasis of the entire room.

Although she is a bit out of place amid the colorful Limoges enamels and decorated ceramic plates, I am drawn to appreciate the way she anchors the display case. Bare, vulnerable, and impolite amid the decorous—the enamels, the men, the myths, and the gloss of the large seventeenth-century bronzes in other galleries—she feels contemporary in spirit and form. The precision and strength of this figure extend to its sparse presentation. Balanced on a very fine, slender foot with a tiny counterbalance on the toe of the opposite foot, she touches "ground" perched on a plain plinth rather than a traditional pedestal. Without a companion—no animal, no plant, no grasping lover or saint, not even a scrap of draped cloth—she is not "presented" and thus is more heroic and urgent. Over time, I note that her fierce eyes glisten with tiny silver implants that are matched by erotic punctuations of silver at the tips of her nipples. The placement of these four spots of light makes her skin darker, more beautiful, and enhances the nuances in the patina. I cannot help thinking about the moment the sculptor inserted these tiny solid silver rods into the bronze (no mere welds for this beauty), just as I cannot stop feeling the intense delight he (assumed because women were not granted the honor of sculpting) must have derived in modeling the inside of the hands and every pubic hair.

Bronze is no skin of paint sitting on canvas; time and attention are melted into the density of the material. The artist first models in clay, then plaster, followed by wax, and plaster again, until the wax is dissolved and replaced with liquid bronze. After the cooled metal casting is released from the plaster shell, a great deal of grinding, carving, and polishing completes the process. Absorbed into the object is so much touching and handling that the thing very nearly becomes a power object, a talisman. As the form gains power, it reflects the artist's experience of falling in love with the work.

Making a small work is an unforgiving process. There is no room for missteps, and the *Shouting Woman* is an example of exquisite perfection, her bold demeanor wrought with great feeling and delicacy. The plush palace that is the Frick becomes eminently more compelling when I visit with this giant of a sculpture.

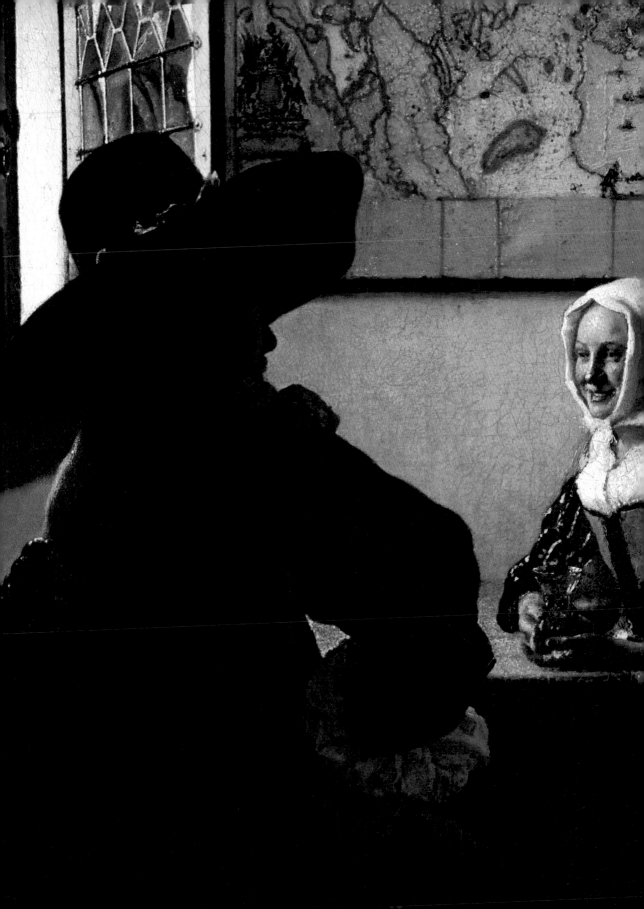

JUDITH THURMAN

Johannes Vermeer, *Officer and Laughing Girl*, ca. 1657

I realized, walking through the Frick one rainy Sunday, that the artists I love most, in any genre, are those who do the greatest justice to women in both senses: aesthetic and political. I knew I would write about one of the museum's three Vermeers; in the end, *Officer and Laughing Girl* struck me as the most heretical.

Vermeer, like Flaubert, is the rare male artist who quickens his women rather than simply molding them. Vermeer invented Flaubertian realism three hundred years before *Madame Bovary*. Working slowly, neither man left a large body of work. "A writer," Thomas Mann said, "is someone for whom writing is harder than for other people." A perfectionist is someone who despairs of perfection yet will not make concessions in the struggle to approach it. The same radiant precision thrills and mystifies in Flaubert's sentences and Vermeer's brushstrokes—a fidelity to the minutest details of a surface, a gesture, an emotion.

Their biographies were almost comically dissimilar. Flaubert was a lifelong bachelor. After an adventurous youth, he retired to his mother's house in Rouen, barricading himself against what he called "le vrai"—the distractions of real life. Vermeer, an art dealer by trade (no one knows how he learned to paint), married at twenty-one and fathered fifteen children. Of the eleven who survived, seven were daughters. The family lived with his wife's rich mother. Their household, it would seem, was gynocentric, if not gynocratic. Is that why men figure so rarely in Vermeer's painting? Or did they not interest him?

"Write about what you know." Well, Vermeer knew women. But that old saw belongs in Flaubert's *Dictionary of Received Ideas*. On the contrary: artists have to discover what they *do not* know that they know. Recovered truth generates a shock of revelation that cannot be counterfeited. In the work of a master—a virtuoso both of technique and feeling—the wonderment does not dissipate, even in the course of centuries.

When feminists bridle at "the male gaze," they are less troubled, I think, by the fact that male artists have looked at women with lust or, at the other extreme, with a worshipful disregard for their carnality than by their habit of regarding us complacently. Complacency is the nemesis of attunement: the effort to vibrate in time and space, in art or life, with another being. When people speak of Vermeer's "genius for intimacy," I think that vibration is what they sense.

Spatially and socially, *Officer and Laughing Girl* represents an unequal encounter both within the frame and within the society the figures inhabit. Yet despite the soldier's exaggerated scale and density, the swagger of his pose, and the richness of his garb, Vermeer subordinates him and treats him generically. Is he not also mocking conspicuous virility? Does he not suggest that the silhouette defines the man? Then what of the girl, so vibrantly an individual? Vermeer, it is true, invites us to imagine how the soldier regards her—probably as a conquest. Yet he himself humbly refuses to possess her. Thus neither can we. She belongs to herself.

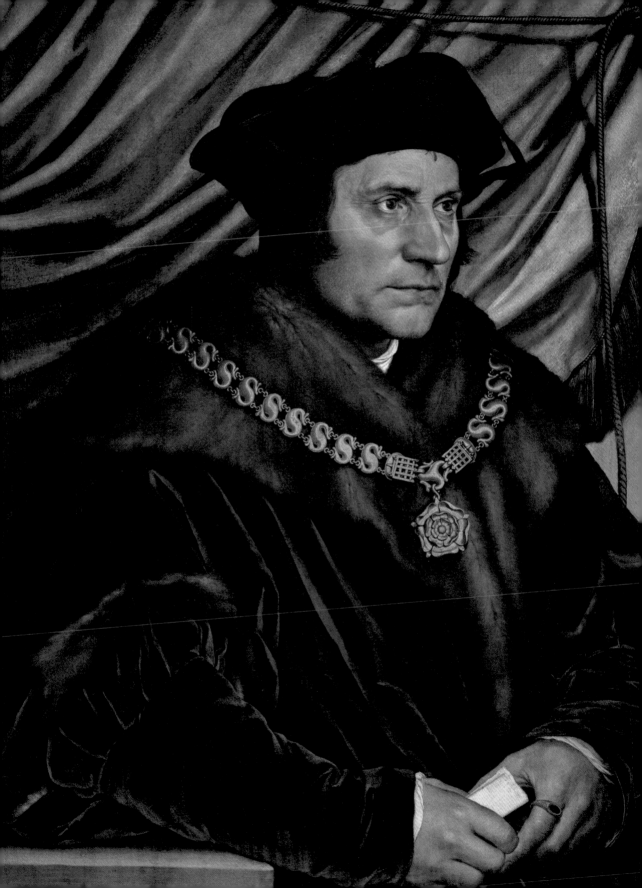

COLM TÓIBÍN

Hans Holbein the Younger, *Sir Thomas More*, 1527

Sir Thomas More's face, in the painting by Holbein, has an expression that suggests calmness, evenness of spirit, reticence. His robes and his chain let us know that he is powerful, but his pose—the way he almost joins his hands, the small strands of hair that peep from under his cap—offers us, on first look, an image of uncertainty, humility. He is even-tempered but also not proud or vehement or imposing, but neither is he simple or easy to fathom. The more you study the face the more you see a stubbornness and a forcefulness in the gaze. More appears as someone who is fully alone in this portrait, who has been alone a great deal in his life, who may be more comfortable in a library or in a church than in merry company. The gaze is not withering or judgmental, but it has a penetrating edge nonetheless, a hint of pure determination, and shows that the sitter cares about the life of the mind. Thomas More, in Holbein's portrait, has an inner strength; he has an awkward pale handsomeness as he moves into middle age. He looks like a man more at ease in shadow than in sunlight, happier when silent, a man with a rich way of noticing.

Holbein worked in a time when the face, when captured by an artist, released accurate or secret information about the soul, the spirit, the self. The more detailed the work done on surface expression and the more complexity and ambiguity given to the face, the more we feel satisfied. We search the outer signs for the inner meaning. When, for example, Holbein paints someone as powerful as More, we look for something beyond the power, beneath the surface shine; we seek some element of weakness or pride or even cruelty that will suggest character and fate, will signal what is within.

Sometimes, when the portrait is, like this one, of a politician, when it is of someone worldly and secular rather than a saint—More was not canonized until 1935—we get not only a spare northern version of the sitter and his or her inner life but also a cold version of our fate on the earth. The gaze in this portrait exudes a fragility both temporal and spiritual, intensely personal but also suggestive of some larger question. The portrait shows a sort of dry austerity and dignity in More and recognizes that he, like the rest of us, was but dust, and to dust he shall return.

Part of the power of the portrait comes from its pure worldliness. The folds in the background cloth and the sumptuousness of the clothes More is wearing pull in the eye. The fur collar, created with rich, fuzzy brushwork, and the sleeve covering More's right arm, filled with dazzling texture, serve to make the calm flesh tones on the hands and face all the more interesting. The cap itself, painted a dense black, anchors the painting with its flatness. All the folds—in the green backdrop, in the dark tunic, in the opulent material of the sleeves—create a sense of movement and untidiness against the placidity and stillness of the face.

What is strange is that Thomas More, despite the lack of pride in his expression, does not seem overwhelmed by the richness all around him. He lives easily and intensely in the world of power. The gaze, the more you study it, is oddly fearless, utterly clear eyed, the gaze of a man at home in the world of high politics, a man whom you would not treat lightly or easily underestimate.

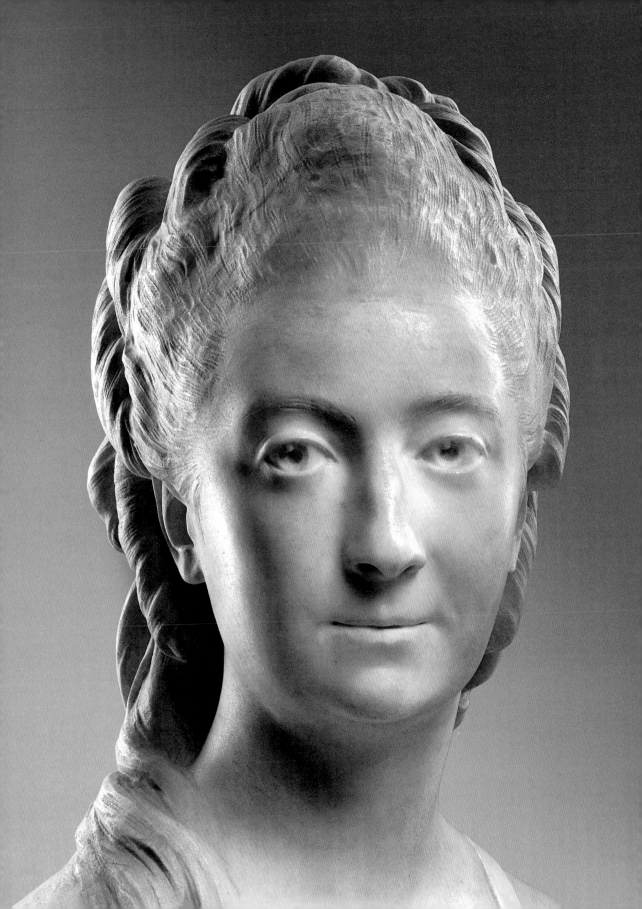

CHRIS WARE

Jean-Antoine Houdon, *Madame His,* **1775; and** *Armand-Thomas Hue, Marquis de Miromesnil,* **1777**

There are few uncooler-sounding words than "eighteenth-century marble portraiture." Even typing these words makes me feel like I'm prepping for the PSAT. But eighteenth-century marble portraiture—specifically that of Jean-Antoine Houdon, known for his uncool likenesses of Voltaire and George Washington—can be extraordinarily strange. Furthermore, the examples here are nearly nowhere to be found on your phone except in lo-res preview form. In other words, you have to actually go to the Frick to see them.

Two busts, sculpted within two years of each other, are paired in an out-of-the-way hall of the museum: a woman, *Madame His,* and a man, *Armand-Thomas Hue.* Translucent, actual-sized, people-shaped white rocks carved in Enlightenment dress and balanced atop quadrangular pedestals at eyeball height, both are lopped off somewhere above the waist and function as the sort of thing that museum-going twenty-first-century humans are likely to walk right past and think, "Oh, art." Which is just what I did, on my way to the Bellini painting I'd planned to write about. But something stopped me. *Madame His* doesn't look like the major-ity of eighteenth-century painted portraits I'd seen, which largely crash-land somewhere in flyover caricature country: big watery eyes, boiled-egg chins, tiny red lips. As I circled the bust, I increasingly admired how it substantiated my mental template of "actual human being," how Houdon had worked outside his epoch's stylizations. I was surprised by how the marble skin seemed to suggest hidden muscles and tendons, by how the slightly rougher fabric of the bodice lightly met her soft shoulders. Then I looked up, and something even more surprising happened: Madame His met my gaze.

As any kid with a crayon knows, the human eye is attuned to finding faces. Two dots will fix the seen for the seer, and vice versa; we are constantly seeking to pin other consciousnesses down, catching in our headlights the thoughts of others at our shared twin fulcrums of empathy. That ubiquitous 1975 smiling yellow disc proves it. But in art, it's up to the artist's skill and sensitivity whether the sensation of life or the sentiment of "have a nice day" is the result. So it's to Houdon's credit that at that moment in front of *Madame His,* the chasm of the centuries sprang together, and I felt, if just for a moment, like I was uncannily and most genuinely in the presence of someone two hundred years dead. Even more painfully, if I moved ever so slightly one way or the other, she turned once again to stone (not unlike the passengers on the plane with whom I'd traveled to New York, nearly all of whom had closed the shades of their windows to more effectively bury themselves in the light of their screens).

On that flight, I'd sat next to a sixtyish woman in an alarmingly bright red dress. (Her dress was the detail I remembered most as I'd only gotten in a couple of sidelong glances at her, but I also noted her frizzy chest-nut hair, square silver earrings, and slightly downturned nose.) Despite more than two hours spent sipping complimentary soft drinks and crinkling pretzel bags within five uncomfortable inches of each other, we—agreeably—didn't exchange a word and parted at the LaGuardia jet bridge forever. I had completely forgotten about her until the following morning at the Frick, when I looked over from a painted slice of the Renaissance and there she was, right next to me, again: the same alarming red dress, the same frizzy hair, same square silver earrings, same nose. I began to seek the right words to try to express how fabulously weird it was, here in a city

of millions, that we'd cross paths twice. But she clearly hadn't noticed me either on the plane or at that moment, and she turned and walked away.

Madame His's hallway companion in eternity, Armand-Thomas Hue, won't look at you either. Try as you might, you absolutely will not be able to meet his eyes. I wonder if this was Jean-Antoine Houdon's subtle aim, as it ultimately says more about his subject and is almost more of an artistic accomplishment than what he managed with Madame His—and also because it's what most of us spend our lives actually doing.

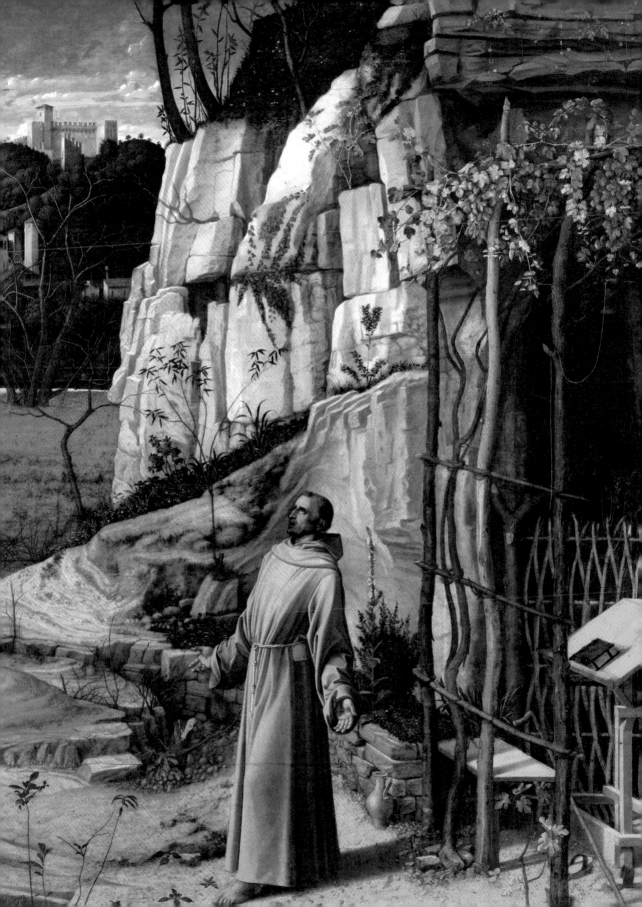

DARREN WATERSTON

Giovanni Bellini, *St. Francis in the Desert*, ca. 1476–78

I first encountered Bellini's *St. Francis in the Desert* in a darkened lecture hall while taking my first Renaissance art history class. I was so moved by the beauty and strangeness of this image, even in its dim, scratchy projection. As a young painter, I had never before been so curious about and so affected by a work of art. I asked my professor to tell me everything he knew about the painting, where it was and whether he had ever seen it. He told me I must make a trip to New York—it would be my first—to see the painting at The Frick Collection.

I saved up enough money to fly to New York that winter break. I wasn't religious, but here I was making a proper pilgrimage to see this painting. I remember feeling a nervous anticipation as I approached the Frick, as if I were meeting a lost relative or a new lover for the first time. I made my way through the museum's sumptuous galleries and hallways and finally found myself standing in front of the painting—sweaty palmed, fraught with emotion, my mouth agape just like Bellini's St. Francis. The painting was more beautiful and mysterious than I could have imagined. I went back the next day to see other works at the museum, but I kept returning to the Bellini, moved by the desire to look at it again and again. That day, I bought a postcard of the painting, and it has been pinned to every easel in every studio I have had since. Creased at the corners and splattered with paint, the old postcard is an emblem of the first time I ever felt transformed by a work of art. As I've grown as an artist, this singular painting has been a constant revelation, and I have returned to the Frick to see *St. Francis in the Desert* every year of my life since that first encounter.

Bellini is as enigmatic as his subject, the two of them bound in the invented shadows of his impossible landscape, cast in that strange azure light. He contains the saint in oil and pigment, caught in ecstasy, mouth open, arms open, hands open. Could St. Francis hold that stance for eternity if it were not for Bellini?

I return to the painting over and over, to study the molten cliff face, the crevices between things, the hiding places to shelter the interior thoughts of a hare or a hermit . . . and myself. Alone in the wilderness of his making, perhaps Bellini also imagined being there among the juniper, fig, and grafted tree, where every leafless branch and even the ground where St. Francis stands gives pleasure.

A few questions I have always wanted to ask Bellini:

Did the heron and the ass see what St. Francis saw?
Are the seraphim resting behind the overgrown laurel?
Is that Jerome's skull?
Did the grapevine ever bear fruit?
Did the shepherd ever look up?
When you painted him, did your face look like his?

EDMUND WHITE

Clodion (Claude Michel), *Zephyrus and Flora*, 1799

I've always had an admiration for the bravado, the speed, even the joyful immorality of the Rococo, and for me that dazzling period is best expressed in the art of the sculptor Claude Michel, better known simply as Clodion (originally, the name of a fifth-century Merovingian king, a sort of priest-king whose strength, like Samson's, resided in his long hair).

As if through the magic of his assumed name, Clodion the sculptor was the plaything of aristocrats and the rich bourgeoisie. He specialized in vivid figures in terracotta or marble or bronze. The Frick's *Zephyrus and Flora* is just a few inches tall but the two figures (and the putti at their feet) are rendered with exquisite detail. Zephyrus, the god of the west wind, is shown as he is about to embrace Flora, the goddess of spring.

In the nineteenth century, critics often discussed art as a frozen moment, something equivalent today to a still in a movie. I remember a nineteenth-century discussion of Hiram Powers's *Greek Slave*, a sculpture that was the hit of the Crystal Palace; the statue was praised not for its formal qualities (as we would approach it) but because the artist had chosen the exact moment when the slave breaks free of her bonds. By the same token, we can praise the Clodion sculpture because it shows the very moment when the two divinities are about to embrace and, pulled down by the little cupids, about to dissolve into an erotic puddle.

They are both very young—no more than fifteen, I'd guess. Zephyrus's ribs are showing, and his neck is long and thin; the features of both are sharp and not rounded off by pudginess or slackening muscles. The ideal slenderness, the finely rendered traits, Flora's lei of flowers, the compact but detailed bodies—they are perfection itself, the kind that has never indulged in manual labor or anything more demanding than sipping ambrosia.

Perhaps to animate his small sculptures, Clodion often portrayed reckless frolics—bacchanalia, a waking satyr, and a sleeping nymph. Slender arms punching the sky; sturdy legs or hairy hooves striding forth, drunken, ecstatic figures in riotous contrapposto—this was a way of giving an outsize energy to his miniatures.

The Frick, of course, houses the many panels Fragonard painted at the same period, *The Progress of Love*, a masterpiece of youth, frivolity, and sensuality. Another Rococo master was Boucher, who said of real-life nature, "Too green and badly lit." These sculptors and painters improved on nature with their enchanted bosks, their garlands of flowers, the demi-tints of shadows, their fountains, their statues of a sleeping Silenus.

The saddest thing is to think that these artists of the aristocracy saw their elegant world vanish in the chaos and bloodshed of the revolution. Clodion left Paris and returned to his native Nancy, where he was reduced to home decoration. He died on the very eve of Napoleon's defeat.

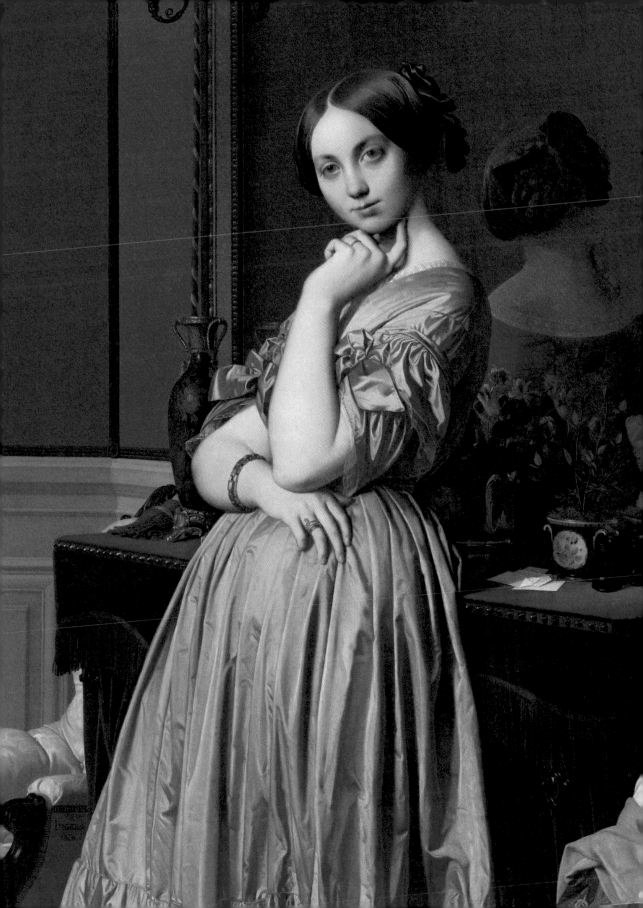

Jean-Auguste-Dominique Ingres, *Comtesse d'Haussonville*, 1845

STEEL VELVET

THERE THERE THERE ís THERE ARE THERE ís THAT THAT ís
Always the space behind, a mirror that makes the space in front strong and mysterious
AN outward gaze, AN inner gaze exACTítude of THíNGS
exACTítude of THíNGS
exACTítude of THíNGS exACTly and exACTly
ARCHíTECTURE of LíNES of vertical and horizontal interrupted by curves
ARCHíTECTURE of LíNES BENEATH THE Comtesse TRACED DíAGONAL LíNES
ARCHíTECTURE OF LíNES supporting her, creating tension FOR HER Portrait
SPACE
exACTítude oF THíNGS of cool BLUES
of gold accents THíS AGAíNST THAT THAT makes THAT THAT íS
THAT íS THíS and THíS ís ís THAT íS WHAT íT íS
WHAT íT íS always
WHAT íT íS íS ALWAYS íS CLASSíCAL
CLASSíCALLy
CLASSíCALLY THíS AND THAT íS THAT ís ís ís THíS
ARCHíTECTURE oF LíNES eLBOW AgAíNST HAND Exactly and Exactly
Gold against blue FíNGER AGAíNST JAW RED against bLACK
EXACTLY AND EXACTLY EXACTíTUDE oF THíNGS ExActLY
THíS íS íS THAT THAT íS THAT MAKE ít WHAT ít íS
EXACTLY WHAT íT íS EXACTLY THAT ANd THAT ís THAT
ALWAYS AND ALWAYS CLASSíCALLY ALíGNED ARCHíTÉturally
THíS íS THAT BECAUSE THíS ís INGRES ís OURs TODAY AND ALL Days
ALWAYS and ALWAYS A MíRROR BEHíND
exACTítude oF THíNGS
ex ACTítude oF THíNGS
exACTítude oF THíNGS
ONE EYE LOOKs OUTWARD and one EYE LOOKs WíTHíN
EXACTLY AND EXACTLY

CONTRIBUTORS

ANDRÉ ACIMAN is an American writer who was born and raised in Alexandria, Egypt. He is the author of many books, among them, *Call Me by Your Name* (2007), which was adapted into an Oscar-winning film of the same title, and its sequel, *Find Me* (2019). He is Distinguished Professor of Comparative Literature at the Graduate Center of the City University of New York.

IDA APPLEBROOG is an American multi-media artist whose work is in the collections of many museums, including the Metropolitan Museum of Art, the Museum of Modern Art, the Guggenheim Museum, and the Pushkin State Museum. She received a MacArthur Fellowship in 1998.

FIRELEI BÁEZ is an artist of Haitian-Dominican descent whose work has been shown at the ICA/Boston Watershed and the Schomburg Center for Research in Black Culture, among others. Her solo exhibition *Blood-lines* (2015) was presented at the Pérez Art Museum Miami and the Andy Warhol Museum. She has received numerous awards, including the United States Artists Fellowship (2019).

VICTORIA BECKHAM is a British businesswoman and creative director who achieved fame as one of the Spice Girls before going on to launch the Victoria Beckham and Victoria Beckham Beauty brands in 2008 and 2019, respectively.

TOM BIANCHI is an American painter, sculptor, author, and photographer whose photo monographs include *Men I've Loved: Prose, Poems, and Pictures* (1998) and *In Defense of Beauty* (1995), among others. His most recent book is *'63 E. 9th Street: NYC Polaroids 1975–1983* (2019).

CARTER BREY is an American cello virtuoso and Principal Cello, the Fan Fox and Leslie R. Samuels Chair, of the New York Philharmonic. He plays a violoncello made by G. B. Guadagnini in Milan in 1754.

ROSANNE CASH is an American singer and songwriter, as well as the author of several books, most recently, *Bird on a Blade* (2018). She has won four Grammy awards and is the recipient of the 2020 Edward MacDowell Medal. Her memoir *Composed* (2010) was a *New York Times* bestseller.

JEROME CHARYN is an American novelist, essayist, and short story writer whose most recent book is *Cesare: A Novel of War-Torn Berlin* (2020). Charyn has been a finalist for the PEN/Faulkner Award for Fiction and was awarded a Guggenheim Fellowship in 1983. He has been named Commander of Arts and Letters by the French Minister of Culture.

ROZ CHAST is an American cartoonist and longtime contributor of cartoons and covers to *The New Yorker*. Her graphic memoir *Can't We Talk about Something More Pleasant?* (2014) won a National Book Critics Circle Award and was a finalist for the National Book Award.

GEORGE CONDO is an American artist whose work has been the subject of solo exhibitions at the Phillips Collection (2017) and the New Museum (2011). Early in his career, he briefly worked at Andy Warhol's Factory and played in the punk rock band The Girls. His work is in important public and private collections around the world.

GREGORY CREWDSON is an American photographer who creates staged pictures within the American vernacular landscape. His work is widely exhibited internationally. He is Director of Graduate Studies in Photography at the Yale University School of Art.

JOHN CURRIN is an American figurative painter who has had retrospective exhibitions at the Whitney Museum of American Art and the Museum of Contemporary Art Chicago. His work is featured in the permanent collections of major art museums, among them, the Hirshhorn Museum and Sculpture Garden and the Tate galleries.

JOAN K. DAVIDSON, an American philanthropist, is President Emerita of the J. M. Kaplan Fund. She was Chair of the New York State Council on the Arts and Commissioner of the New York State Office of Parks, Recreation and Historic Preservation and now presides over two Kaplan Fund programs she founded, Furthermore grants in publishing and the Alice award for illustrated books.

LYDIA DAVIS is an American writer best known for her extremely short stories. She is also a translator of books from French to English, among them, Proust's *Swann's Way*. She has received numerous awards, including a MacArthur Fellowship in 2003 and the Man Booker International Prize in 2013.

EDMUND DE WAAL is a British artist and writer. His work has been exhibited worldwide in museums such as The Frick Collection, the Jewish Museum and Ateneo Veneto in Venice, the Kunsthistorisches Museum, and the Victoria and Albert Museum. He is the author of the bestselling family memoir *The Hare with Amber Eyes* (2010) and *The White Road* (2015).

RINEKE DIJKSTRA is a Dutch photographer whose work has been shown in major museums around the world. A retrospective was presented in 2012 at the Guggenheim Museum and the San Francisco Museum of Modern Art. Her most recent exhibition was the video installation *Night Watching* at the Rijksmuseum.

MARK DOTY is an American poet and memoirist. He received a National Book Award for *Fire to Fire: New and Selected Poems* (2008). Doty is the first American poet to have won Great Britain's T. S. Eliot Prize, for *My Alexandria* (1993), which also received the Los Angeles Times Book Prize and the National Book Critics Circle Award.

LENA DUNHAM is an American writer, director, and producer who was the creator and star of the hit series *Girls* (2012–17). She is the author of *Not That Kind of Girl: A Young Woman Tells You What She's "Learned"* (2014) and the director of the forthcoming film *Catherine, Called Birdy*. She paints with watercolors.

STEPHEN ELLCOCK is a London-based writer and collector of images who has created a museum of images on Facebook and Instagram. He is the author of *All Good Things: A Treasury of Images to Uplift the Spirits and Reawaken Wonder* (2019).

DONALD FAGEN is an American musician and co-founder of the band Steely Dan, which in 2001 was inducted into the Rock and Roll Hall of Fame. He is the author of the memoir *Eminent Hipsters* (2013).

RACHEL FEINSTEIN is an American painter and sculptor whose work has been included in numerous shows worldwide. *Maiden, Mother, Crone,* a survey of her work, was presented at the Jewish Museum in New York in 2019.

TERESITA FERNÁNDEZ is an American conceptual artist known for her unconventional use of materials and monumental public artworks. Her work has been exhibited extensively both nationally and internationally. She is a 2005 MacArthur Fellow and the recipient of numerous other awards, including a Guggenheim Fellowship.

BRYAN FERRY is an English musician and singer who first came to prominence as founder of the band Roxy Music before embarking on a solo career. In 2011, he was made a Commander of the British Empire for his services to music and in 2019 was inducted into the Rock and Roll Hall of Fame.

MICHAEL FRANK, an American writer, is the author of the novel *What Is Missing* (2019) and the memoir *The Mighty Franks* (2017), which won the 2018 JQ Wingate Prize.

MOEKO FUJII is a Japanese writer and critic whose essays have appeared in *The New Yorker*, *Aperture* magazine, *The Point*, and elsewhere.

ADAM GOPNIK, an American writer, is on the staff of *The New Yorker* and the author of numerous books, among them, *A Thousand Small Sanities: The Moral Adventure of Liberalism* (2019), *Winter: Five Windows on the Season* (2011), and *Paris to the Moon* (2000).

VIVIAN GORNICK is an American critic, journalist, essayist, memoirist, and the author of many books, most recently, *Unfinished Business: Notes of a Chronic Re-Reader* (2020). Her writing has appeared in *The New York Times*, *The Nation*, *The New York Review of Books*, *The Atlantic*, and many other publications.

AGNES GUND is an American philanthropist and former president of the Museum of Modern Art. In 2017, she founded the Art for Justice Fund initiative in partnership with the Ford Foundation to support criminal justice reform in the United States. In 2018, she was awarded the J. Paul Getty Medal for extraordinary contributions to the practice, understanding, and support of the arts.

CAROLINA HERRERA is a Venezuelan-American fashion designer and founder of the eponymous fashion house. She has received many industry accolades, among them, the Lifetime Achievement Award from the Council of Fashion Designers of America (2008), and the Womenswear Designer of the Year (2004).

ALEXANDRA HOROWITZ, an American scientist, teaches at Barnard College of Columbia University and heads the Horowitz Dog Cognition Lab. Among her publications are the bestselling *Inside of a Dog: What Dogs See, Smell, and Know* (2009), *On Looking: A Walker's Guide to the Art of Observation* (2014), and *Our Dogs, Ourselves* (2019).

ABBI JACOBSON is an American actor, writer, producer, director, and illustrator, and a co-creator and star of the television series *Broad City* (2014–19). She is the author of *I Might Regret This* (2018) and *Carry This Book* (2016). She hosted the *A Piece of Work* podcast in partnership with MoMA on WNYC.

BILL T. JONES is an American dancer, director, choreographer, author, the co-founding artistic director of Bill T. Jones/Arnie Zane Company, and the founding artistic director of New York Live Arts. Among many accolades, he is the recipient of the National Medal of the Arts, the Kennedy Center Award, and a MacArthur Fellowship.

MAIRA KALMAN is an Israeli-born American artist, writer, and designer who has written and illustrated thirty books. A frequent contributor to *The New Yorker* and columnist for *The New York Times*, she has also designed clocks and other objects for the Museum of Modern Art, fabric for Isaac Mizrahi, and sets for the Mark Morris Dance Group.

NINA KATCHADOURIAN is an American interdisciplinary artist whose work was the subject of *Nina Katchadourian: Curiouser*, a traveling survey organized by the Blanton Museum of Art at the University of Texas at Austin in 2017. Her work has been exhibited at the Venice Biennale and is in the collections of the San Francisco Museum of Modern Art, the Metropolitan Museum of Art, and the Morgan Library & Museum.

SUSANNA KAYSEN is an American writer best known for her memoir *Girl, Interrupted* (1993), named after the Frick's *Girl Interrupted at Her Music* by Vermeer and later made into a film.

JONATHAN LETHEM is an American novelist, essayist, and short story writer. He won a National Book Critics Circle Award for *Motherless Brooklyn* (1999), adapted into a film of the same title, and was awarded a MacArthur Fellowship in 2005.

KATE D. LEVIN is a Principal at Bloomberg Associates and oversees the Bloomberg Philanthropies Arts Program. She served as Commissioner of the New York City Department of Cultural Affairs from 2002 to 2013.

DAVID MASELLO is an American writer whose essays, features, and poetry have appeared in many publications and anthologies, including *The Best American Essays*. He is the author of three books about architecture and public art and also a playwright with multiple productions.

JULIE MEHRETU is an Ethiopian-born American artist who has participated in numerous international exhibitions and has had solo shows at the Guggenheim (2010), the Museo de Arte Contemporáneo de Castilla y León (2006), and the Walker Art Center (2003). She has received numerous awards, among them, a MacArthur Fellowship (2005).

DANIEL MENDELSOHN is an American memoirist, critic, essayist, and translator whose books include *An Odyssey: A Father, a Son, and an Epic* (2017) and *The Lost: A Search for Six of Six Million* (2006), among others. He is Editor-at-Large of *The New York Review of Books* and Director of the Robert B. Silvers Foundation.

RICK MEYEROWITZ is an American illustrator and author who was a regular contributor to the *National Lampoon* for many years. His book *Drunk Stoned Brilliant Dead* (2010), a history of the *National Lampoon*, was adapted for a documentary with the same title. With Maira Kalman, he created *The New Yorker*'s iconic "New Yorkistan" cover.

DUANE MICHALS is an American artist whose work has been the subject of numerous solo exhibitions and is in major collections such as the Art Institute of Chicago, the Smithsonian Institution, the Metropolitan Museum of Art, and the Bibliothèque Nationale, Paris.

SUSAN MINOT, an American author, writes short stories, novels, poetry, plays, and films and has painted all her life. Among her books are *Thirty Girls* (2014), *Rapture* (2002), *Evening* (1998), which was adapted into the feature film of the same name, and *Monkeys* (1986). She also wrote the screenplay of Bernardo Bertolucci's *Stealing Beauty*. Her most recent book is *Why I Don't Write and Other Stories* (2020).

MARK MORRIS is an American choreographer who has created more than 150 works for the Mark Morris Dance Group, conducted orchestras, directed operas, and choreographed for ballet companies worldwide. He has received numerous awards, among them, a MacArthur Fellowship (1991).

NICO MUHLY is an American composer, pianist, arranger, and conductor. He has written more than one hundred works for the concert stage, including the opera *Marnie* (2017), which premiered at the English National Opera and was staged by the Metropolitan Opera.

VIK MUNIZ is a Brazilian photographer and mixed-media artist. His work was the subject of the Oscar-nominated documentary *Waste Land* (2010). His photographs are in many museum collections, including the Metropolitan Museum of Art, the Museum of Modern Art, the Tate galleries, and the Victoria and Albert Museum.

WANGECHI MUTU is a Kenyan-American artist known for her sculptures, paintings, videos, and installations. Her work is included in such collections as the Museum of Modern Art, the Studio Museum in Harlem, and the Whitney Museum of American Art. In 2019, she created sculptures for the first of the annual commissions for the facade niches of the Metropolitan Museum of Art.

CATHERINE OPIE is an American photographer whose work has been presented at the Whitney Biennial (2004 and 1995) and in solo shows at the Los Angeles County Museum of Art (2016 and 2010) and the Guggenheim Museum (2008). She is chair of the Art Department at the University of California at Los Angeles (UCLA).

JED PERL is an American art critic and regular contributor to *The New York Review of Books*. Among his many books are *Calder: The Conquest of Time* (2017), *Magicians and Charlatans: Essays on Art and Culture* (2012), and *Antoine's Alphabet: Watteau and His World* (2008).

TAYLOR M. POLITES is an American writer and educator and the author of *The Rebel Wife* (2012). His writing has appeared in anthologies, as well as arts and news publications. He teaches at the Rhode Island School of Design and the Maslow Family Creative Writing MFA program at Wilkes University.

DIANA RIGG (d. September 2020) was an English actor who, among many roles, played Emma Peel on the television series *The Avengers* (1965–68) and Olenna Tyrell on the HBO television series *Game of Thrones* (2013–17).

JENNY SAVILLE is a British painter and an original member of the Young British Artists. Her work has been exhibited widely and is included in a number of museum collections, among them, the Metropolitan Museum of Art, the Broad Museum, and the San Francisco Museum of Modern Art.

SIMON SCHAMA, a British writer and critic, is University Professor of Art History and History at Columbia University and a Contributing Editor of the *Financial Times*. He is the author of nineteen award-winning books and the writer-presenter of fifty documentaries on art, history, and literature for BBC2 and PBS.

LLOYD SCHWARTZ, an American critic and poet, is the classical music critic for National Public Radio's *Fresh Air* with Terry Gross. His most recent volume of poems is *Little Kisses* (2017), and he is co-editor of *Elizabeth Bishop: Poems, Prose, and Letters* (2008). In 1994, he was awarded the Pulitzer Prize for criticism.

ANNABELLE SELLDORF, a German-born architect, is Principal of Selldorf Architects, an award-winning practice she founded in 1988 in New York. The firm has designed many museums, art galleries, and other cultural projects and is currently working on the expansion and renovation of The Frick Collection.

ARLENE SHECHET is an American sculptor whose work has been the subject of numerous solo exhibitions and can be found in many public and private collections. In 2016–17, the Frick presented *Porcelain, No Simple Matter: Arlene Shechet and the Arnhold Collection*, which juxtaposed her work with eighteenth-century pieces produced by the Royal Meissen Manufactory.

JUDITH THURMAN, an American writer, is a staff writer at *The New Yorker*. She is the author of *Cleopatra's Nose* (2007), a collection of her essays; *Secrets of the Flesh, A Life of Colette* (1999), winner of the Los Angeles Times Book Prize; and *Isak Dinesen: The Life of a Storyteller* (1983), which won a National Book Award.

COLM TÓIBÍN, an Irish writer, is the author of nine novels, including *Brooklyn* (2009) and *The Master* (2005). He is Irene and Sidney B. Silverman Professor of the Humanities at Columbia University. In 2017–18, he co-curated *Henry James and American Painting*, an exhibition that was presented at the Morgan Library & Museum and the Isabella Stewart Gardner Museum.

CHRIS WARE is an American writer and artist who has contributed graphic fiction and covers to *The New Yorker*. Among his numerous books are *Rusty Brown* (2019) and *Jimmy Corrigan: The Smartest Kid on Earth* (2000), which won the Guardian Prize in 2000. His work has been exhibited at the Whitney Museum of American Art and the Jewish Museum in New York, among others.

DARREN WATERSTON is an American artist whose paintings, works on paper, and installations are in the collections of such museums as the Seattle Art Museum and the Getty Research Institute. Recent solo exhibitions include *Filthy Lucre: Whistler's Peacock Room Reimagined* (2020) and *Uncertain Beauty* (2014).

EDMUND WHITE is an American author who has written nearly thirty books, most recently, *A Saint from Texas* (2020). In 2019, he received the Medal for Distinguished Contribution to American Letters from the National Book Foundation. White is professor emeritus of creative writing at Princeton.

ROBERT WILSON is an American visual artist, director, and playwright known for his theater works and collaborations with artists, writers, and musicians. He has had exhibitions at the Louvre Museum and the San Francisco Museum of Modern Art, among others, and his work is in the collections of such institutions as the Museum of Modern Art and the Centre Pompidou. His many awards include the Golden Lion at the Venice Biennale.

152

Bastiani, Lazzaro (documented 1456–1512)
Adoration of the Magi, 1470s. Tempera on poplar panel, 20½ × 11 in. Purchased by The Frick Collection, 1935 (1935.1.130) page 85

Bellini, Giovanni (ca. 1424/1435–1516)
St. Francis in the Desert, ca. 1476–78. Oil on panel, 49¹/₁₆ × 55⅞ in. (panel), 48⅞ × 55⁵/₁₆ in. (image). Henry Clay Frick Bequest (1915.1.03) pages 51, 141

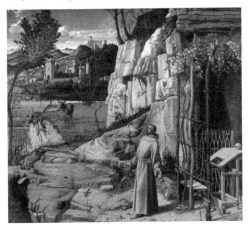

Bronzino, Agnolo (Agnolo di Cosimo) (1503–1572)
Lodovico Capponi, ca. 1550–55. Oil on poplar panel, 45⅞ × 33¾ in. Henry Clay Frick Bequest (1915.1.19) pages 81, 87, 93, 113, 129

Chardin, Jean-Siméon (1699–1779)
Still Life with Plums, ca. 1730. Oil on canvas (lined), 17¾ × 19¾ in. Purchased by The Frick Collection, 1945 (1945.1.152) pages 39, 75

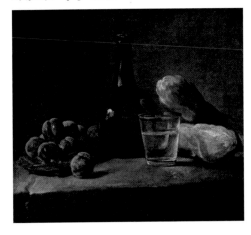

Clodion (Claude Michel) (1738–1814)
Zephyrus and Flora, 1799. Terracotta,
h. 23 in. Henry Clay Frick Bequest
(1915.2.76) page 143

Duccio di Buoninsegna (ca. 1255–ca. 1319)
The Temptation of Christ on the Mountain, 1308–11. Tempera
on poplar panel (cradled), 17 × 18⅞ in. Purchased by The
Frick Collection, 1927 (1927.1.35) pages 103, 105

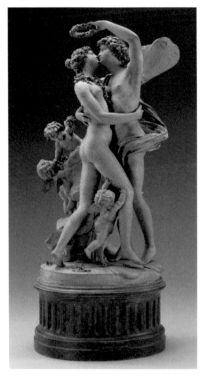

Corot, Jean-Baptiste-Camille (1796–1875)
Ville-d'Avray, ca. 1860. Oil on canvas (lined), 17¼ × 29¼ in.
Henry Clay Frick Bequest (1898.1.27) page 13

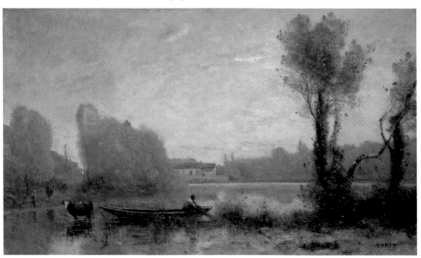

Fragonard, Jean-Honoré (1732–1806)
The Progress of Love: The Pursuit, 1771–72. Oil on
canvas, 125⅛ × 84⅞ in. Henry Clay Frick Bequest
(1915.1.45) page 49

Fragonard, Jean-Honoré (1732–1806)
The Progress of Love: The Lover Crowned, 1771–72.
Oil on canvas (lined), 125⅛ × 95¾ in. Henry Clay
Frick Bequest (1915.1.48) page 49

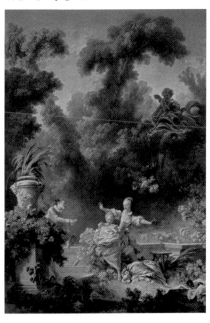

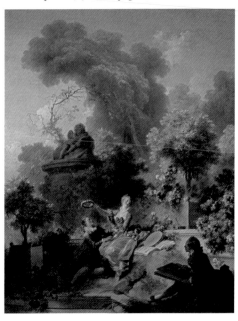

Fragonard, Jean-Honoré (1732–1806)
The Progress of Love: The Meeting, 1771–72. Oil on
canvas, 125 × 96 in. Henry Clay Frick Bequest
(1915.1.46) page 49

Fragonard, Jean-Honoré (1732–1806)
The Progress of Love: Love Letters, 1771–72. Oil on
canvas, 124⅞ × 85⅜ in. Henry Clay Frick Bequest
(1915.1.47) page 49

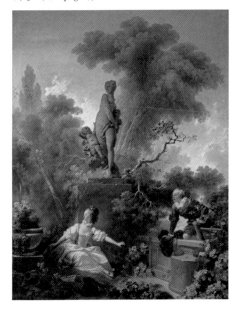

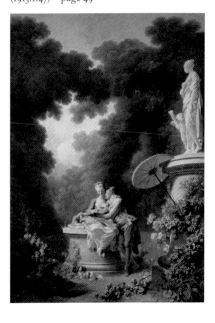

Gainsborough, Thomas (1727–1788)
The Hon. Frances Duncombe, ca. 1777. Oil on canvas,
92¼ × 61⅞ in. Henry Clay Frick Bequest
(1911.1.61) page 57

Gainsborough, Thomas (1727–1788)
Mrs. Peter William Baker, 1781. Oil on canvas,
89⅝ × 59¾ in. Henry Clay Frick Bequest
(1917.1.59) page 57

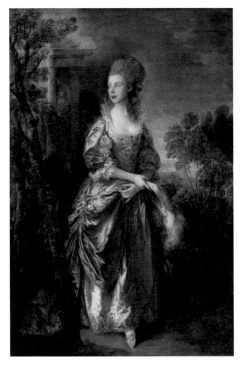

Gainsborough, Thomas (1727–1788)
Grace Dalrymple Elliott, ca. 1782. Oil on canvas
(lined), 30⅞ × 25 in. Purchased by The Frick
Collection, 1946 (1946.1.153) page 57

Gainsborough, Thomas (1727–1788)
The Mall in St. James's Park, ca. 1783. Oil on canvas,
47½ × 57⅞ in. Henry Clay Frick Bequest (1916.1.62)
pages 57, 71

Goya y Lucientes, Francisco de (1746–1828)
Don Pedro, Duque de Osuna, ca. 1790s. Oil on canvas, 44½ × 32¾ in. Purchased by The Frick Collection, 1943 (1943.1.151) page 69

Goya y Lucientes, Francisco de (1746–1828)
Portrait of a Lady (María Martínez de Puga?), 1824. Oil on canvas, 31½ × 23 in. Henry Clay Frick Bequest (1914.1.63) page 77

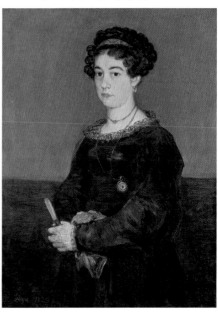

Goya y Lucientes, Francisco de (1746–1828)
The Forge, ca. 1815–20. Oil on canvas, 71½ × 49¼ in. Henry Clay Frick Bequest (1914.1.65) page 21

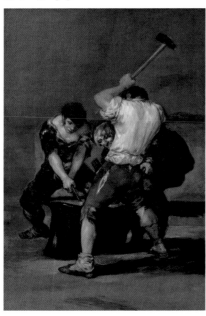

Greuze, Jean-Baptiste (1725–1805)
Madame Baptiste aîné, ca. 1790. Pastel on cream paper, 18 × 14⅜ in. Purchased by The Frick Collection with funds bequeathed in memory of Suzanne and Denise Falk, 1996 (1996.3.127) page 45

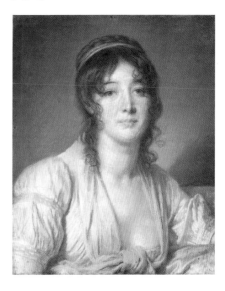

Holbein, Hans, the Younger (1497/1498–1543)
Sir Thomas More, 1527. Oil on oak panel, 29½ × 23¾ in.
Henry Clay Frick Bequest (1912.1.77)
pages 79, 83, 113, 135

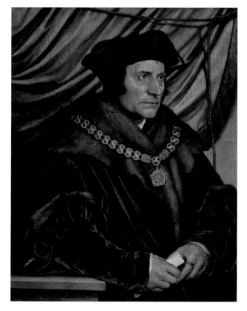

Houdon, Jean-Antoine (1741–1828)
Armand-Thomas Hue, Marquis de Miromesnil, 1777.
Marble, h. 25½ in. Purchased by The Frick Collection,
1935 (1935.2.78) page 137

Holbein, Hans, the Younger (1497/1498–1543)
Thomas Cromwell, 1532–33. Oil on oak panel (cradled),
30¾ × 25¼ in. Henry Clay Frick Bequest
(1915.1.76) page 25

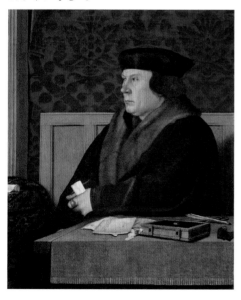

Houdon, Jean-Antoine (1741–1828)
Madame His, 1775. Marble, h. 31½ in. Gift of
Mr. and Mrs. Eugene Victor Thaw, 2007
(2007.2.01) page 137

Ingres, Jean-Auguste-Dominique (1780–1867)
Comtesse d'Haussonville, 1845. Oil on canvas,
51⅞ × 36¼ in. Purchased by The Frick
Collection, 1927 (1927.1.81) pages 17, 115, 145

Lawrence, Thomas, Sir (1769–1830)
Julia, Lady Peel, 1827. Oil on canvas, 35¾ × 27⅞ in.
Henry Clay Frick Bequest (1904.1.83) page 117

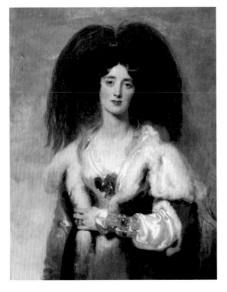

Liotard, Jean-Étienne (1702–1789)
Trompe l'Oeil, 1771. Oil on silk transferred to canvas,
9⅜ × 12¾ in. Bequeathed by Lore Heinemann in
memory of her husband, Dr. Rudolph J. Heinemann,
1997 (1997.1.182) page 109

Manet, Édouard (1832–1883)
The Bullfight, 1864. Oil on canvas, 18⅞ × 42⅞ in.
Henry Clay Frick Bequest (1914.1.86) page 53

Meissen Porcelain Manufactory (act. 1710–present)
Two Birds of Paradise, model by Johann Joachim
Kändler (1775–1706), ca. 1733. Hard-paste porcelain,
h. 9¼ in. each. Gift of Henry H. Arnhold, 2019
(2016.9.19). page 73

Piero della Francesca (ca. 1411/1413–1492)
St. John the Evangelist, ca. 1454–69. Tempera on
poplar panel, 52¾ × 24½ in. Purchased by The Frick
Collection, 1936 (1936.1.138) page 67

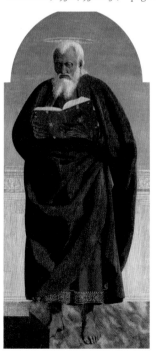

Rembrandt Harmensz. van Rijn (1606–1669)
The Polish Rider, ca. 1655. Oil on canvas, 46 × 53⅞ in.
Henry Clay Frick Bequest (1910.1.98) page 27

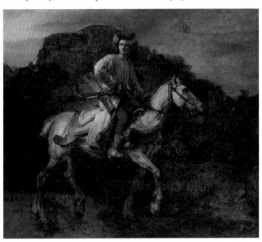

Rembrandt Harmensz. van Rijn (1606–1669)
Self-Portrait, 1658. Oil on canvas, 52⅝ × 40⅞ in.
Henry Clay Frick Bequest (1906.1.97)
pages 29, 41, 89, 119, 121

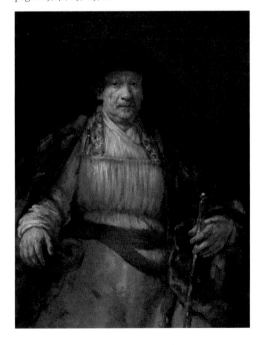

Romney, George (1734–1802)
Lady Hamilton as "Nature," 1782. Oil on canvas,
29⅞ × 24¾ in. Henry Clay Frick Bequest
(1904.1.103) page 23

Titian (Tiziano Vecellio) (ca. 1488–1576)
Portrait of a Man in a Red Cap, ca. 1510. Oil on
canvas, 32⅜ × 28 in. Henry Clay Frick Bequest
(1915.1.116) page 81

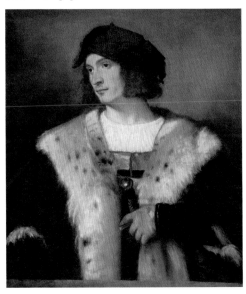

Tiepolo, Giambattista (1696–1770)
Perseus and Andromeda, ca. 1730–31. Oil on canvas,
20⅜ × 16 in. Henry Clay Frick Bequest
(1916.1.114) page 35

Turner, Joseph Mallord William (1775–1851)
Harbor of Dieppe: Changement de Domicile,
exhibited 1825, but subsequently dated 1826. Oil on
canvas, 68⅜ × 88¾ in. Henry Clay Frick Bequest
(1914.1.122) page 97

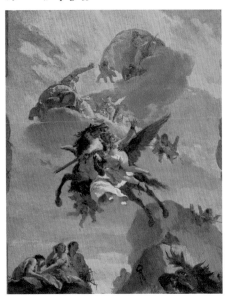

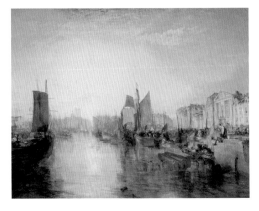

Turner, Joseph Mallord William (1775–1851)
Mortlake Terrace: Early Summer Morning, 1826. Oil on
canvas (lined), 36⅝ × 48½ in. Henry Clay Frick
Bequest (1909.1.121) page 123

Unknown artist (Mantua?)
Nude Female Figure (*Shouting Woman*), early 16th
century. Bronze, h. 10½ in. Henry Clay Frick
Bequest (1916.2.14) pages 111, 131

Van Dyck, Anthony (1599–1641)
Marchesa Giovanna Cattaneo, 1622–27. Oil on
canvas (lined), 40⅜ × 34 in. Henry Clay Frick
Bequest (1907.1.41) page 43

Velázquez, Diego Rodríguez de Silva y (1599–1660)
King Philip IV of Spain, 1644. Oil on canvas,
51⅞ × 39⅞ in. Henry Clay Frick Bequest
(1911.1.123) page 31

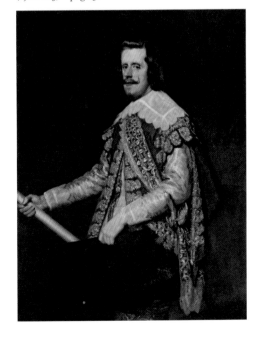

Vermeer, Johannes (1632–1675)
Officer and Laughing Girl, ca. 1657. Oil on
canvas (lined), 19⅞ × 18⅞ in. Henry Clay Frick
Bequest (1911.1.127) pages 19, 61, 125, 133

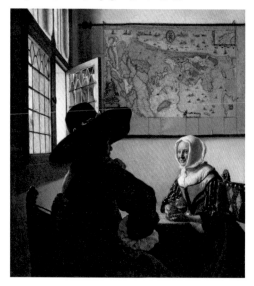

Vermeer, Johannes (1632–1675)
Mistress and Maid, 1666–67. Oil on canvas,
35½ × 31 in. Henry Clay Frick Bequest (1919.1.126)
pages 65, 101

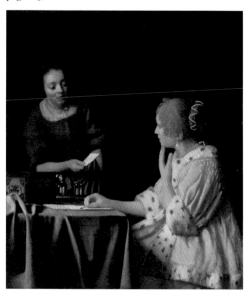

Vermeer, Johannes (1632–1675)
Girl Interrupted at Her Music, ca. 1658–59. Oil on
canvas, 15½ × 17½ in. Henry Clay Frick Bequest
(1901.1.125) pages 33, 59

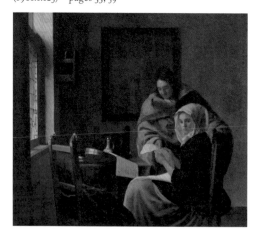

Watteau, Jean-Antoine (1684–1721)
The Portal of Valenciennes, ca. 1710–11. Oil on canvas
(lined), 12¾ × 16 in. Purchased with funds from the
bequest of Arthemise Redpath, 1991
(1991.1.173) page 99

Whistler, James McNeill (1834–1903)
Harmony in Pink and Grey: Portrait of Lady Meux,
1881–82. Oil on canvas, 76¼ × 36⅝ in. Henry Clay
Frick Bequest (1918.1.132) page 15

Whistler, James McNeill (1834–1903)
*Arrangement in Black and Gold: Comte Robert de
Montesquiou-Fezensac*, 1891–92. Oil on canvas,
82⅞ × 36⅞ in. Henry Clay Frick Bequest
(1914.1.131) page 63

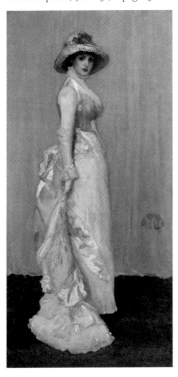

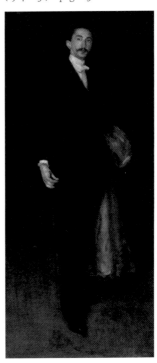

Whistler, James McNeill (1834–1903)
Symphony in Grey and Green: The Ocean, 1866. Oil on
canvas, 31¾ × 40⅞ in. Henry Clay Frick Bequest
(1914.1.135) page 47

Circle of Konrad Witz (ca. 1400–ca. 1447)
Pietà, ca. 1440. Tempera and oil on panel, 13⅞ × 17½ in.
Gift of Miss Helen Clay Frick, 1981 (1981.1.172)
page 37

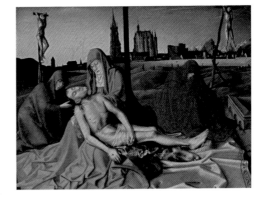

ACKNOWLEDGMENTS

164 It has been a great privilege to be the handmaiden to the creation of these wonderful texts—an absorbing counterpoint to my work on the scholarly books typical of the Frick's publications. We are finishing the work on this book during a time when the world has been turned upside down by the coronavirus pandemic. I like to think that by the time of publication, physical visits to museums and galleries and the potent experience of engaging with a work of art will be among the many restored, and restorative, activities.

First and foremost, I am enormously grateful to the sixty-two contributors, for carving out time in their busy lives to make this book possible. Their texts are by turns confessional, contemplative, academic, even comedic. All are engaging testaments not only to the authors' affection for the Frick and for specific artworks in the collection but, more generally, to the deep emotional response, inspiration, and enrichment that can come from connecting with a work of art.

I am indebted to Adam Gopnik, who, very early on, signed on to contribute a text and later generously agreed to write a foreword as well. Ian Wardropper, Anna-Maria and Stephen Kellen Director, and Xavier F. Salomon, Deputy Director and Peter Jay Sharp Chief Curator, have been supportive throughout the development of the book, and for that I am extremely grateful. Xavier, in particular, has been an integral part of the project, and, as is always the case, his input and guidance have been invaluable.

A number of colleagues and other friends have given me suggestions for contributors or helped with a contact here and there. My deepest thanks go to Persephone Allen, Tia Chapman, Edmund de Waal, Betty Eveillard, Caitlin Henningsen, Gerri Hirshey, Maira Kalman, Alison Lonshein, Sarah McNear, Aimee Ng, Alexander Noelle, Jenna Nugent, Klaus Ottmann, Patricia L Rubin, and Darren Waterston. A great many dealers, agents, studio managers, and publicists have helped me to gain access to the contributors and have patiently put up with my relentless pestering; to them goes my deepest appreciation, as well as my apologies.

A special thanks to Jonathan Lethem for letting me co-opt for the title a line from his evocative text in this book and to Darren Waterston, whose dinner-party recounting of his yearly visits from the West Coast to the Frick to commune with *St. Francis in the Desert* was the inspiration for this book.

Christopher Snow Hopkins, Assistant Editor at the Frick, has provided his usual excellent contributions to the editing and proofreading of the texts and to many other aspects of the book's production. I would also like to acknowledge Chris's predecessor, Hilary Becker, who was at the Frick for the earliest stages of this project, as well as my long-time friend and editorial volunteer Serena Rattazzi. Thanks also to Rozemarijn Landsman, for her first-rate translation from the Dutch of Rineke Dijkstra's text; Michael Bodycomb and Joe Coscia Jr., for their accomplished photography; George Koelle for his help with aspects of the color proofing; Stephanie Bernabei for her superb work securing the funding; Eileen Boxer, for her fabulous design of the book; and Mary DelMonico and Karen Farquhar at DelMonico·D.A.P., our ace publishing partner.

On behalf of everyone at the Frick, I would like to acknowledge The Arthur F. and Alice E. Adams Charitable Foundation. We are enormously grateful for the foundation's very generous support of this publication.

Finally, this book is dedicated to David, my very own Renaissance man.

Michaelyn Mitchell
Editor in Chief, The Frick Collection

THE SLEEVE SHOULD BE ILLEGAL

& Other Reflections on Art at the Frick

This publication is made possible by The Arthur F. and Alice E. Adams Charitable Foundation.

"This Is Just To Say" by William Carlos Williams, from *The Collected Poems: Volume I, 1909–1939* © 1938 by New Directions Publishing Corp. Reprinted by permission of New Directions Publishing Corp.

Note on the title: "The sleeve should be illegal" is a line from Jonathan Lethem's text in this volume.

First published in 2021 by The Frick Collection in association with DelMonico Books • D.A.P. New York

The Frick Collection
1 East 70th Street
New York, NY 10021
frick.org

Michaelyn Mitchell, Editor in Chief
Christopher Snow Hopkins, Assistant Editor

DelMonico Books
Available through ARTBOOK | D.A.P.
75 Broad Street, Suite 630
New York, NY 10004
artbook.com
delmonicobooks.com

Production by Karen Farquhar, DelMonico Books

Designed by Eileen Boxer

Typeset in Myriad Pro SemiCondensed and Caslon Pro

Printed and bound in China

Front cover: Detail from Hans Holbein the Younger, *Sir Thomas More*, 1527

Frontispiece: Detail from Thomas Gainsborough, *The Hon. Frances Duncombe*, ca. 1777

Page 6: Detail from Jean-Honoré Fragonard, *The Progress of Love: The Meeting*, 1771–72

Pages 166–67: Grand Staircase, The Frick Collection

A CIP catalogue record for this book is available from the Library of Congress.

ISBN: 978-1-942884-79-8